IMAGES
of America

NARRAGANSETT
BY-THE-SEA

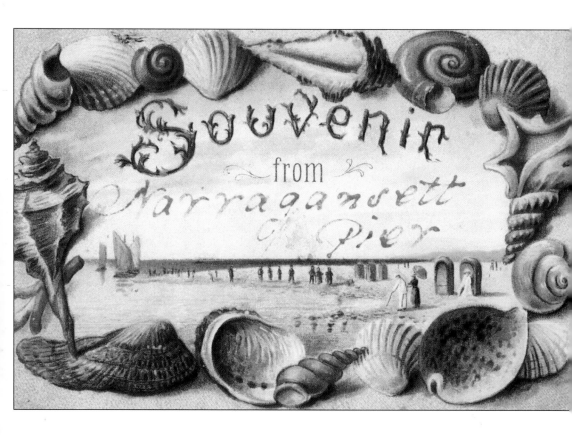

IMAGES
of America

NARRAGANSETT BY-THE-SEA

Sallie W. Latimer

ARCADIA
PUBLISHING

Copyright © 1997 by Sallie W. Latimer
ISBN 978-0-7385-6362-6

Published by Arcadia Publishing
Charleston SC, Chicago IL, Portsmouth NH, San Francisco CA

Printed in the United States of America

Library of Congress Catalog Card Number: 2008937064

For all general information contact Arcadia Publishing at:
Telephone 843-853-2070
Fax 843-853-0044
E-mail sales@arcadiapublishing.com
For customer service and orders:
Toll-Free 1-888-313-2665

Visit us on the Internet at www.arcadiapublishing.com

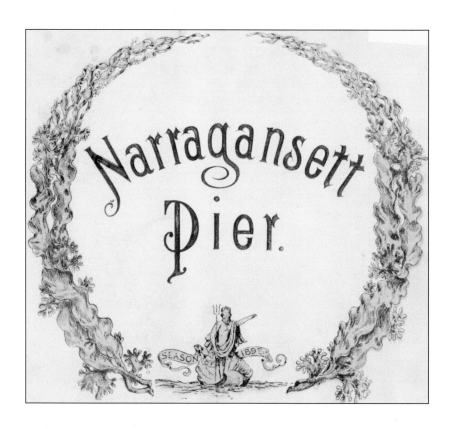

Contents

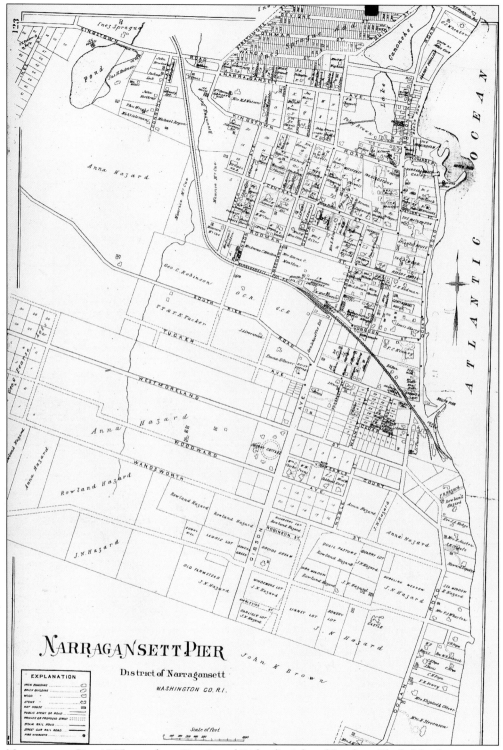

Narragansett Pier 1895 map from *Evert's and Richard's Atlas of Southern Rhode Island.*

Introduction

Narragansett! The wonderful melodious name given to the powerful and prosperous Native American tribe that inhabited southern Rhode Island has become established in the language of our day. It has been called Narragansett Country, Narragansett Bay, Narragansett Pier; yes even Narragansett-by-the-Sea. Scarcely 20 miles long, and less than 2 miles wide, this sliver of land is officially known as the Town of Narragansett.

Bound by Narragansett Bay on the east, Block Island Sound to the south, and Point Judith Pond and the Pettaquamscutt River on the west, it is virtually surrounded by estuaries and ocean. Its geography and climate have nurtured the sweet influences of history and development from Colonial times to the present. The beauty of the land and its exquisite relationship with the water it touches predestined Narragansett to become one of the best known and most fashionable summer resorts on the Atlantic coast.

When I moved to Narragansett some twenty years ago, little remained to testify to the town's golden age. This book is one outcome of a search to find and better understand a rather remarkable history—a history of transformation from a gentle pristine landscape, to a rich agricultural society, to one of America's busiest and most popular seaside resorts.

Come with me, through the pages of this book, back through time to the early years of Narragansett Country, and see the rise of the Narragansett planters. You will experience the means of transportation, by land and by sea, that began to change the character of the area and the people. When the secrets of Narragansett's beautiful beach and delightful climate became more widely known, the wealthy and fashionable came and great wooden hotels began to blossom. Then came the cottages, which signaled the arrival of Narragansett's golden age. The search for exclusivity found its way through the establishment of the Narragansett Casino and Point Judith Country Club. You will gain some insight to questions about how and why all of this happened, even as you marvel at the images of the past.

We are indebted to a small group of professional photographers like Charles E. Thurber, the man known locally as "Reckless Charlie," who have left behind a large number of photographs of people and places. My search for images to illustrate the transformations that took place in Narragansett turned up a large number of twentieth-century images; however, the limits of space in this book suggest that this later part of the story might best be told in another volume. Therefore, we will conclude this episode at the end of Narragansett's golden age, when merchants, manufacturers, statesmen, men of letters and science, and eminent professionals of every sort chose this place as their favorite summer retreat.

Author's Note: The abbreviation NRHP following certain images indicates that the building or buildings featured are listed on the National Register of Historic Places.

One

The Early Years

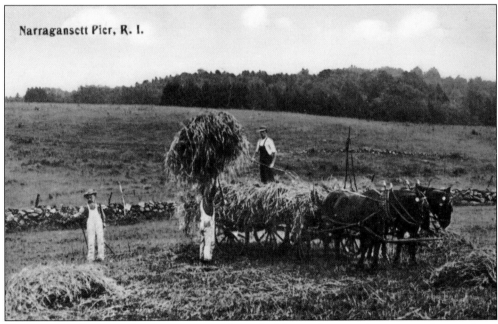

Narragansett Pier, R. I.

Narragansett Country. In the seventeenth and eighteenth centuries, a sparsely populated agricultural society existed in this region. Large farms and plantations, owned by a few families, prospered due to favorable climate, fertile soil, and slave labor. Much wealth was derived from the products of their dairies, flocks of sheep, and splendid horses (called Narragansett pacers). The Sewall farm produced 13,000 pounds of cheese annually.

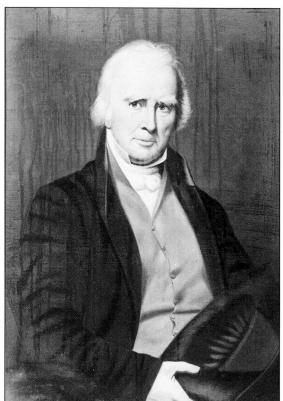

William H. Robinson (1693–1751). The son of Rowland Robinson, who purchased large tracts of land in Narragansett, William greatly enlarged the family holdings and at one time served as deputy governor of the Rhode Island colony. He was an affluent planter and original breeder of the famous horse known as the Narragansett pacer.

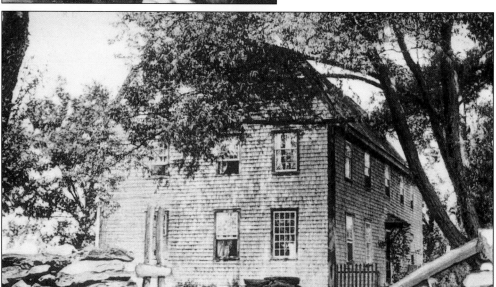

Rowland Robinson House (NRHP), c. 1710. Robinson was among the most prominent of the Narragansett planters, and he also kept large flocks of sheep. The house is located on Old Boston Neck Road and represents one of the finest of its period. The legendary Hannah Robinson, granddaughter of Rowland, was born in this home. "Corn, tobacco, rye, hemp, and flax were important crops on the early farms." (Historic and Architectural Resources of Narragansett, Rhode Island, 1991.)

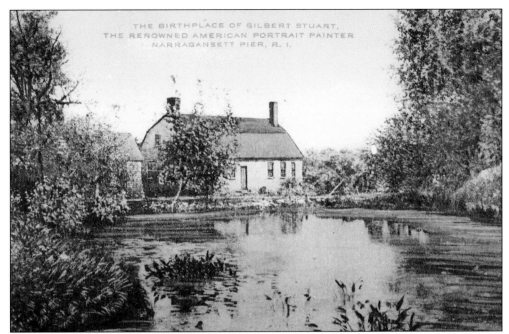

THE BIRTHPLACE OF GILBERT STUART,
THE RENOWNED AMERICAN PORTRAIT PAINTER
NARRAGANSETT PIER, R. I.

Birthplace of Gilbert Stuart. The famous American portrait artist was born in 1755 at this small mill at the head of Pettaquamscutt River. Stuart is best known for his portrait of George Washington which appears on the dollar bill. The snuff mill, operated by his father, was the first in America. Shown here, it blends into a typical landscape of eighteenth-century Narragansett. It remains today a well-known tourist attraction and opens seasonally to the public.

The Bonnet, c. 1880. Soaring 75 feet above Narragansett Bay, this point of land was the location of a battery of canons in 1775 to prevent the passage of ships during the Revolutionary War. Narragansett was spared the destructive occupation of Newport by the British, but did suffer at least three raids when soldiers were seeking sheep and cattle.

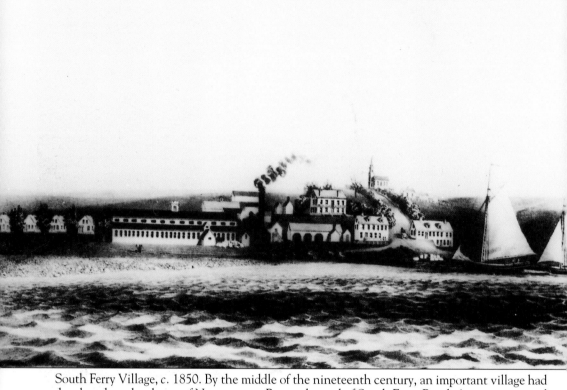

South Ferry Village, *c.* 1850. By the middle of the nineteenth century, an important village had developed on the shores of Narragansett Bay at the end of South Ferry Road. A steam-powered textile mill was manufacturing cotton and woolen goods, and a ferry to Jamestown Island was in operation. Shipbuilding and coastal shipping became important and a large, growing population supported stores, a post office, a school, and a church.

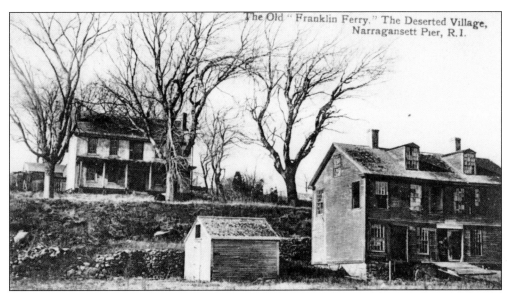

The Old "Franklin Ferry," The Deserted Village, Narragansett Pier, R.I.

South Ferry Village, c. 1900. The once-prosperous village fell on hard times during the Civil War when the flow of Southern cotton was interrupted. Ferry operations to Jamestown were established about 1700 by Abel Franklin, under a ferry charter granted by the Colonial Assembly. The business stayed with the Franklin family for over one hundred years. Several generations are buried across from South Ferry Church. Ferry operations were later moved north to Saunderstown. About the same time, Saunders shipbuilding operations were also moved. The site is now occupied by the University of Rhode Island's Graduate School of Oceanography.

South Ferry Church (NRHP). Remnants of the old South Ferry Village indicate that the church was built in 1850. Prominently sitting on the high point of South Ferry Road, the church has been a landmark for sailors since its construction. Designed by Thomas A. Tefft, the church is one of the state's architectural treasures and is maintained by the University of Rhode Island's Graduate School of Oceanography.

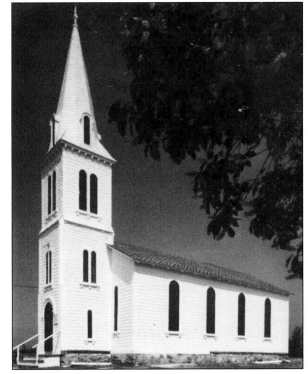

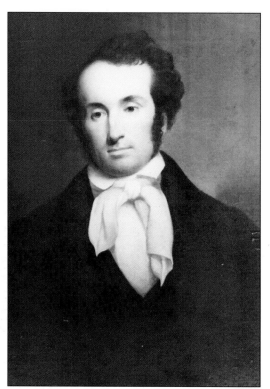

Rowland Gibson Hazard (1801–1888). The son of Rowland Hazard, founder of the Peace Dale Manufacturing Company, Rowland Gibson was not privileged to a classical education. However, he displayed remarkable abilities in two very different arenas by combining a string of successful business ventures with a career as one of the ablest of American writers.

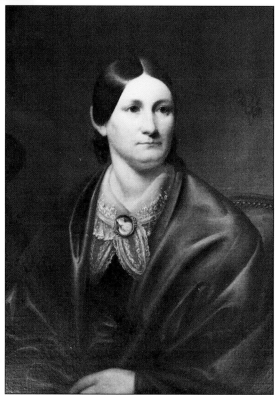

Caroline Newbold Hazard (1807–1866). Caroline was married to Rowland Gibson Hazard on September 25, 1828. Two children were born through this union.

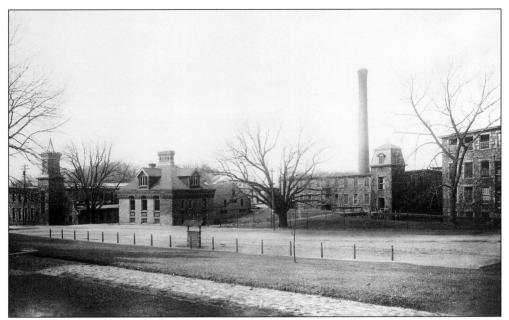

Peace Dale Manufacturing Company (NRHP), *c.* 1892. Founded by Rowland Hazard in 1804 in Peace Dale (named after his mother Mary Peace), the family business grew rapidly. Stone structures seen in the photograph were erected in the 1850s and 1870s. The Hazards greatly influenced Narragansett's development into a seaside resort and brought the first summer visitors to its shores.

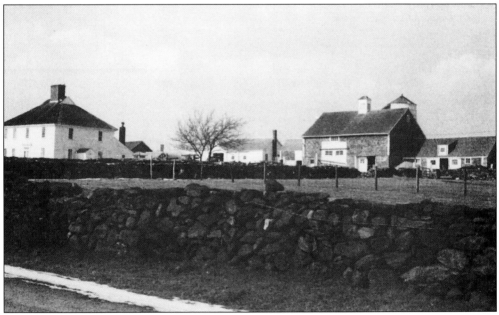

Casey Farm (NRHP), *c.* 1740. This farm, located on Boston Neck Road, is maintained today as a working farm. The old stone walls are typical of New England landscapes and represent a practical solution to the need to prepare the land for cultivation, as well as manage livestock herds. Livestock and their products were a mainstay of the Colonial Narragansett economy. The Society for the Preservation of New England Antiquities now owns the property.

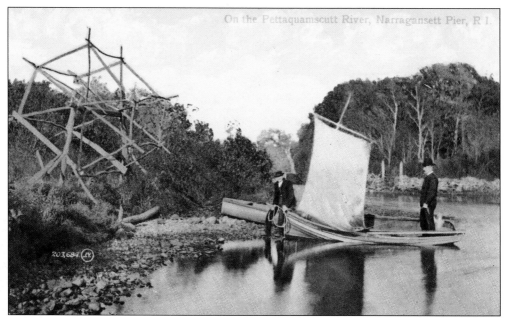

On the Pettaquamscutt, *c.* 1865. Small, locally built boats provided needed transportation and fishing platforms on the Pettaquamscutt River. The Pettaquamscutt is a long narrow estuary on the western side of Narragansett that supported an important fishery, as well as providing sheltered waters for boat building.

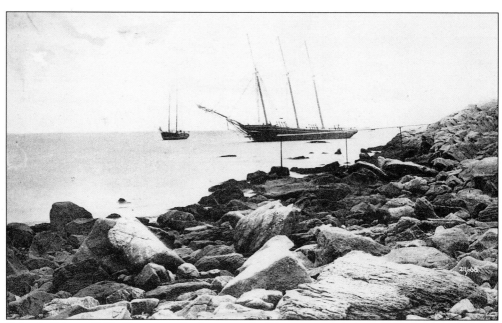

Point Judith, *c.* 1865. Known as the "graveyard of the Atlantic," this rocky point of land that juts out into Block Island Sound marks the site where hundreds of ships have met their demise. The three-masted coastal schooner shown here has gone aground and been abandoned. Heavy shipping traffic in this area and the treacherous currents warranted construction of the first lighthouse in 1806.

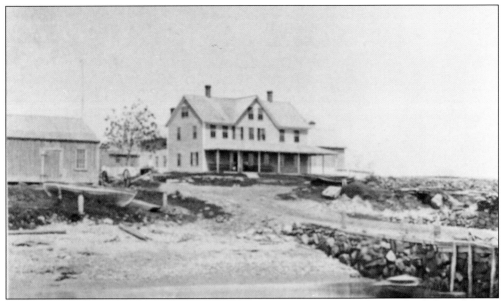

Whaley House, c. 1869. Originally built by Jerry Whaley, the home was enlarged by his son, William E. Whaley, one of the first inhabitants in Narragansett to take in boarders. He would accompany his boarders as a guide to the best fishing grounds in the area. The photograph shows the early development around the South Pier, located at the end of South Pier Road. The original pier was built in 1845 by Joshua Champlin and was used to bring in the lumber and coal sold to residents.

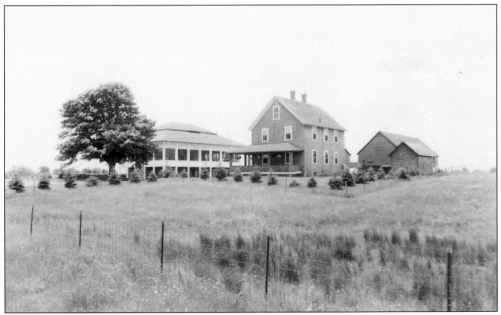

Sunset Farm (NRHP). This plain farmhouse was built in the mid-nineteenth century and is typical of the early farms along Point Judith Road. Behind the house is the Bungalow, a structure built by Francis S. Kinney in 1899. Mr. Kinney, a prominent New York businessman, purchased the farm to convert it into his private country club. He also built Kinney Avenue as a direct route to the Pier. Sunset Farm is now owned by the Town of Narragansett.

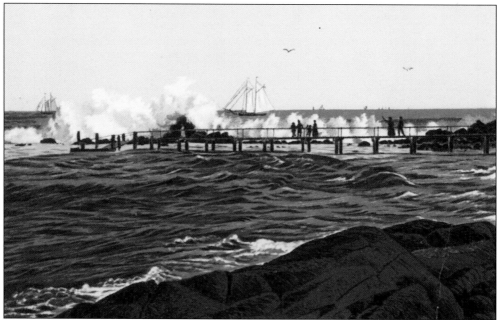

North Pier, c. 1900. Originally built by John Robinson in the 1780s, this became the first of many structures built near the present site of the Towers to provide local farmers a way of exporting and importing goods. Through a succession of owners, the site was rebuilt many times until the 1870s, when much of the commercial activity shifted to South Pier. Small craft continued to use it into the twentieth century.

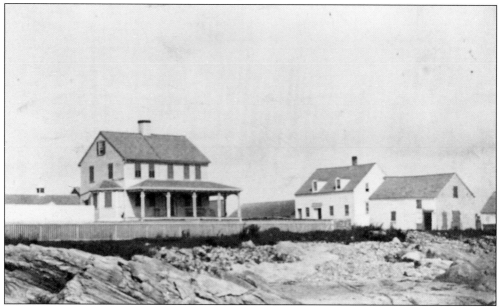

Saunders Coates Cottage, c. 1870. Originally built by George Brown in 1822, the cottage was located on the site now occupied by the Towers. Purchased by Coates as a summer cottage, it was later enlarged, remodeled, and moved to Mathewson Street to make room for the Casino. This early photograph also shows a house, store, and storage building at the site of North Pier. These facilities were owned by J.C. Hazard and W.C. Caswell.

Two

Transportation

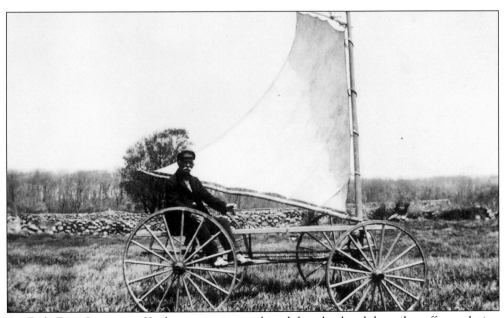

An Early Farm Invention. Yankee ingenuity combined the wheel and the sail to offer a solution to early transportation needs on a large farm. More interesting than practical, the machine demonstrates the combined farmer/fisherman skills of early residents.

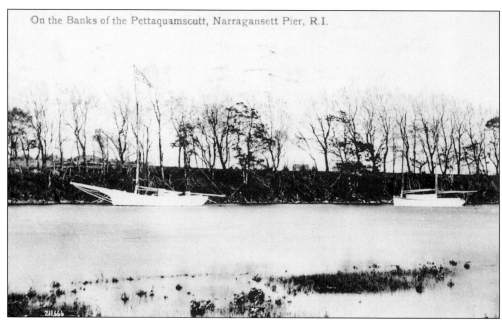

On the Banks of the Pettaquamscutt, Narragansett Pier, R.I.

Boats on the Pettaquamscutt. Nineteenth-century maritime activities included fishing, freighting, and shipbuilding. Coastal schooners and sloops were built on the Pettaquamscutt River, which offered sheltered waters. More than two dozen ships were constructed on the Pettaquamscutt beginning in 1813. The Saunders family moved their shipyard to Saunderstown after 1855.

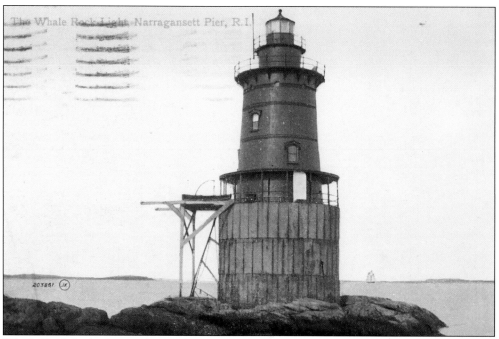

The Whale Rock Light, Narragansett Pier, R.I.

Whale Rock Light. Located near the mouth of Narrow River as an aid to coastal navigation, this conical cast-iron structure was built in 1882 and remained in service until it was destroyed by the hurricane of 1938.

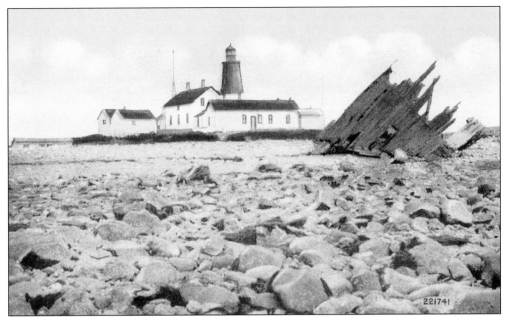

Point Judith Lighthouse (NRHP). The first light was established in 1810 on one of the most exposed and dangerous spots on the east coast. The present lighthouse, dates from 1857 and is the third one on the site. Its light stands 65 feet above sea level and can be seen 17 miles out to sea.

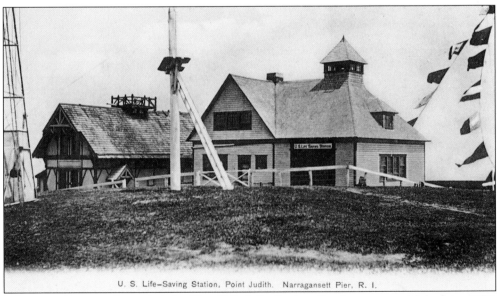

U. S. Life-Saving Station, Point Judith. Narragansett Pier, R. I.

Lifesaving Station, Point Judith. The U.S. Life Saving Service was established in 1870. The structure on the left was built in 1875 and included boat storage and crew quarters. The building on the right was constructed in 1885 to accommodate additional personnel. The service merged with the Revenue Cutter Service in 1915 to form the U.S. Coast Guard. These structures were later removed.

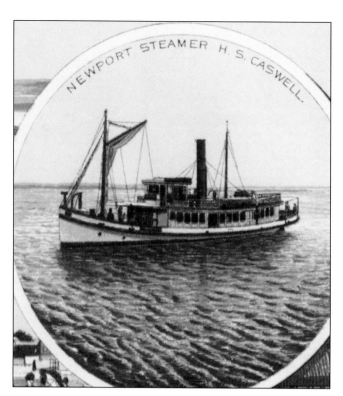

Steamer *H.S. Caswell*. In 1881, the *Herman S. Caswell* and a sister steamer were built for summer passenger traffic between Newport and Narragansett. This direct route took only one hour and was preferred by many who would otherwise come by ferry to Wickford or Saunderstown.

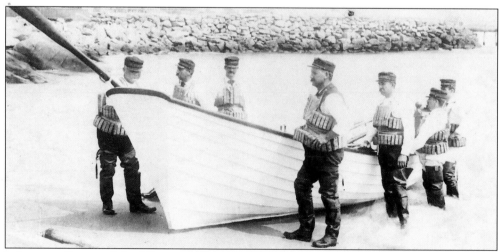

Lifesaving Crew and Surf Boat, *c.* 1888. Surf boat practice was part of a rigorous training regimen for crews. A seven-man crew was required to handle this size boat, which would be launched and rowed out to a ship in distress. It could hold about ten survivors plus a crew depending on weather and water conditions. Multiple boats or trips were required for large shipwrecks.

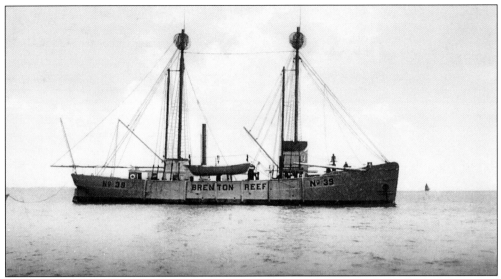

Brenton Reef Light Ship, *c.* 1900. Light ships began service in the 1880s. This wooden vessel had to be towed to its station. Oil was used to generate light, and the twelve-man crew worked thirty-day shifts. Brenton Reef light ships were replaced in 1961 by a "Texas" tower.

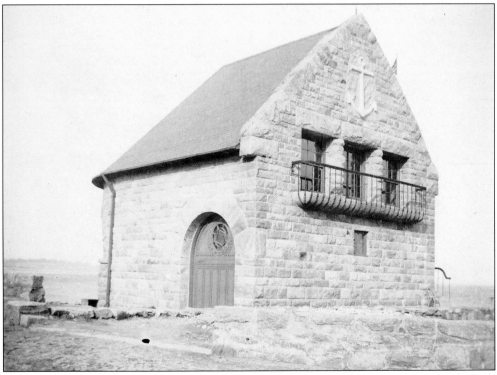

Lifesaving Station at the Pier (NRHP), c. 1888. The first such building in America to be built of stone, it was designed by McKim, Mead and White to harmonize with the Towers. Boat storage occupied the first floor and crew quarters were located on the second. It remained in service until 1937 and is now part of the Coast Guard House restaurant.

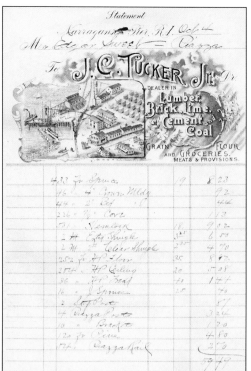

Bill of Lading, c. 1885. The J.C. Tucker Company Dock came into being in 1882, during the time that the company controlled the land and facilities at South Pier. Lumber and coal were the commodities most frequently shipped. The bill shown is an interesting glimpse at the price of lumber and a way of business in the 1880s. J.C. Tucker Company later organized the Wakefield Branch Lumber Company.

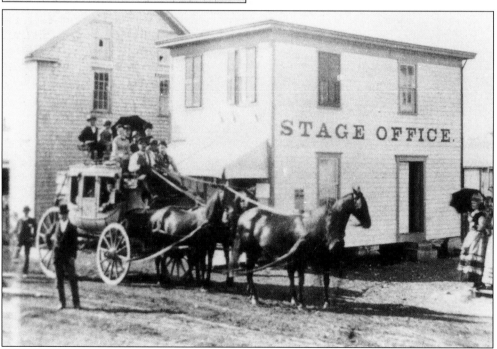

The Stage Office, c. 1875. The stagecoach recalls the romance of the past, but for those who had to endure the rough, dusty, 10-mile ride from Kingston Depot to Narragansett, it was anything but romantic. The office was on Beach Street, but business dropped off rapidly after 1876 with the coming of the railroad.

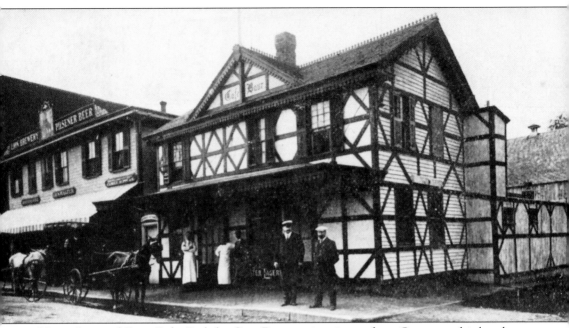

Horse Cart and Baur Café. Built by Otto Baur, an immigrant from Germany, this handsome structure serves as a backdrop for the common, but essential horse cart. Horse power was the only way to go cross-country before the railroad and automobile. No less than five livery stables were located in Pier Village by 1895. Accommodating up to a hundred horses each, these enterprises supported carriage- and harness-makers and blacksmiths, as well as a large farm and feed system. Some summer residents would choose to ship their favorite mounts and grooms which could be boarded at the stables. When the telephone arrived in the 1880s, the stables were connected to hotels and cottages, speeding up a request for an elegant landau, party wagon, or favorite mount.

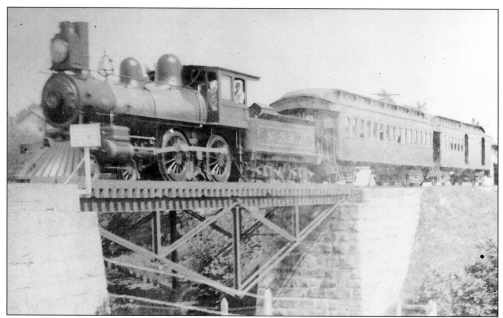

A Short Haul to the Bay. The Narragansett Pier Railroad (NPRR) was built in 1876. The line began at the Providence and Stonington Railroad Station in West Kingston and ended at South Pier in Narragansett, a distance of about 9 miles.

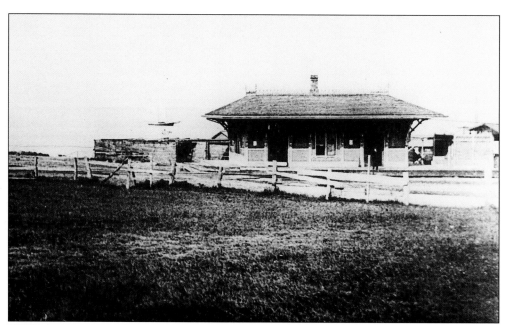

NPRR Station at South Pier. Built in 1876 at the end of the line near Ocean Road, the station was also the site of a turntable and storage facilities. The passenger station was closed in 1887 when the terminal was moved to Boon Street and this structure was used for storage.

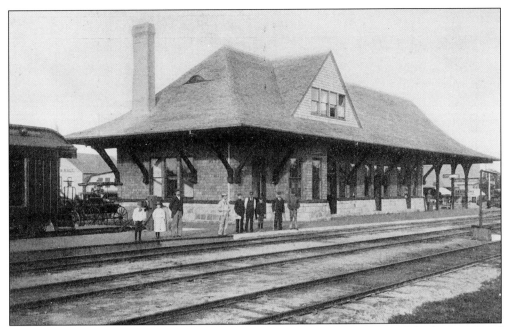

NPRR Station on Boon Street. Built in 1896, it was described as "one of the best arranged passenger buildings" (*A Short Haul to the Bay! A History of the Narragansett Pier Railroad*, 1969). It served the railroad until 1953 when passenger service was terminated to Narragansett. Today it is occupied by an apartment and laundromat.

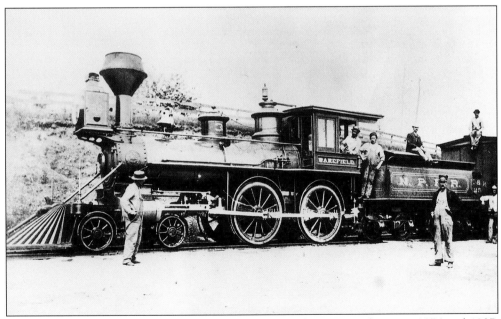

NPRR Steam Locomotive. The NPRR had nine steam locomotives between 1876 and 1937. Engine No. 3, known as the Wakefield, was built and acquired in 1883. In 1890, the railroad carried over a hundred thousand passengers and thousands of tons of freight and baggage. An express run could be made from Kingston to Narragansett in thirteen minutes.

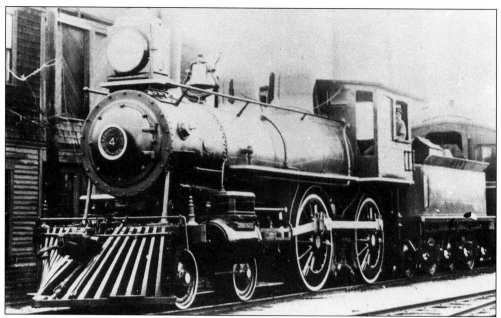

Engine No. 4. Called the Narragansett, this engine was built in Rhode Island in 1891. It was a particular favorite of the engineers. Unable to compete with the automobile and truck, the NPRR began a slow but steady decline during the twentieth century. By 1979, the railroad had lost all of its freight customers and quietly went out of business, ending a long and colorful part of Narragansett history.

Narragansett Pier Railroad.

TIME-TABLE.

Commencing Monday, June 21, 1897.

FROM NARRAGANSETT PIER.

LEAVE.	A M	A M		A M	A M	A M	P M	P M	P M	P M	P M	P M	SUN A M	A M	A M	P M	P M	P M
Narragansett Pier.	7 25	8 30		10 20	11 30	12 25	2 00	4 25	5 15	6 00	7 45	8 45	7 25	10 25	11 30	2 30	6 15	7 15
Wakefield	7 33	8 37		10 27	11 37	12 33	2 08	4 33	5 22	6 08	7 53	8 53	7 33	10 33	11 38	2 38	6 22	7 23
Peace Dale	7 36	8 40		10 30	11 40	12 36	2 11	4 36	5 25	6 11	7 56	8 56	7 36	10 36	11 41	2 41	6 25	7 26
Kingston.. Ar	7 51	8 54		10 45	11 54		2 26	4 51	5 40		8 11		7 51	10 51		2 56	6 40	
Wickford Jun. Ar	8 19	9 19		11 19			3 19	5 19	6 19				8 15			3 15		
East Greenwich "	8 30	9 30		11 30				5 30	6 30				8 27			3 27		
Auburn "									6 53				8 50			3 50		
Providence "	8 50	9 50		11 50			3 18	5 50	7 08				9 05			4 05		
Boston "	10 15	11 15		1 15			4 25	7 15	8 30				10 42			5 42		
Worcester "	11 05	1 10		3 05			5 08	8 10	11 05									
Wood R. Jun..Ar	8 14	9 08		11 14		3 14	5 08	6 14		8 35			9 19	11 18				
Westerly "	8 30	9 23		11 30	12 25	3 30	5 23	6 30		8 50			9 35	11 33			7 14	
Stonington "		9 33		11 40	12 35	3 40	5 33	6 40		9 00			9 45				7 43	
New London "	9 10	9 52		12 10	12 57	3 50	6 00	7 10		P M			10 15				7 43	
New Haven "	11 52	11 52		1 25	2 25	5 05		9 05									9 05	
N. Y. Shore Line "	1 50	1 50		3 00	4 30	6 57		11 00									11 00	
N. Y. Ston. Line "										6 30								
	P M	P M		P M	P M	P M	P M	P M	P M	P M	A M	A M	A M	A M	A M	P M	P M	P M

TO NARRAGANSETT PIER.

LEAVE.	A M	A M	P M	P M	A M	A M	A M	A M	P M	P M	A M	P M	P M	P M	SUN A M	A M	A M	P M	P M	P M
N. Y. Ston. Line ..			6 00	6 00																
N. Y. Shore Line..					5 00					10 03	1 02	1 02								
New Haven						7 55				12 05	2 47	3 00								
New London	6 50	8 00	9 50							1 50	4 00	4 50			6 45					
Stonington	7 21	8 28	10 21							2 21	4 28	5 21			7 16					
Westerly	7 31	8 38	10 31							2 31	4 38	5 31			7 26			2 27		
Wood River Jun.	7 47	8 53	10 47							2 47	4 53	5 47			7 42			2 43		
Worcester						7 50	8 52		10 55	12 56	2 55	4 50								
Boston					6 45	8 45	10 05		12 45	2 45	3 45				8 18				5 00	
Providence		6 52	8 10	10 10	11 15			2 10	4 10	5 10	7 35				9 55				6 05	
Auburn		7 08													10 11					
East Greenwich		7 31	8 31	10 42				2 31	4 31	5 31	7 56				10 34					
Wickford Jun		7 42	8 42					2 42	4 42	5 42	8 07				10 46					
Kingston		8 04	9 06	11 04	11 59			3 04	5 12	6 04	8 21				8 09	11 01		3 00	6 49	
Peace Dale	6 30	7 45	8 15	9 18	11 16	12 10		1 35	3 16	5 24	6 16	8 33			7 03	8 12	11 13	2 13	3 12	7 01
Wakefield	6 33	7 48	8 18	9 21	11 19	12 13		1 38	3 19	5 27	6 19	8 36			7 06	8 15	11 16	2 15	3 15	7 04
Narragan't PierAr	6 41	7 56	8 25	9 28	11 27	12 21		1 46	3 27	5 35	6 27	8 46			7 11	8 23	11 24	2 21	3 23	7 11
	A M	A M	A M	A M	A M	A M		M P	M P	P M	P M	P M			A M	A M	A M	P M	P M	P M

Freight Train will leave Narragansett Pier for Kingston, 12.35 P. M. Return, leave Kingston at 2.30 P. M.

GEO. T. LANPHEAR, Supt.

NPRR Timetable. A summer schedule shows eleven passenger trains leaving Narragansett each weekday and six trains on Sunday. A single freight train was also scheduled each day. This was a busy time for the "little railroad that could."

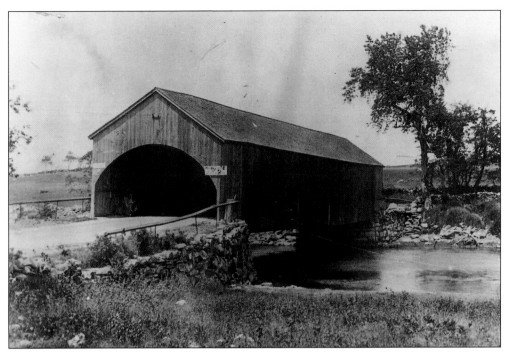

Covered Bridge. In 1868, this bridge was constructed over the Narrow River, and the Boston Neck Road was extended from Saunderstown, opening up an important land link to the Narragansett Pier. The bridge spanned 100 feet and was at the time the longest in Rhode Island. It served the area well until 1921, when the Sprague Memorial Bridge, a reinforced concrete structure, was constructed just east of the site.

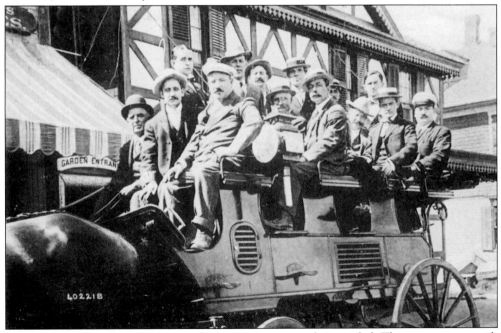

People Mover. Local transportation for large groups was often needed. This interesting coach has a full load of fourteen men who are either going to or from a party.

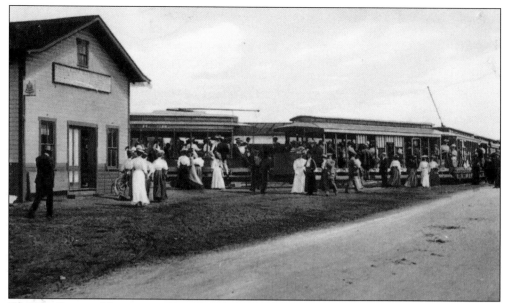

Sea View Station, Narragansett Pier. An electric trolley line called the Sea View was constructed from the Pier to Saunderstown in 1898. Designed to provide alternate passenger access to Narragansett, it was extended to East Greenwich in 1900, where there was a connecting line to Providence.

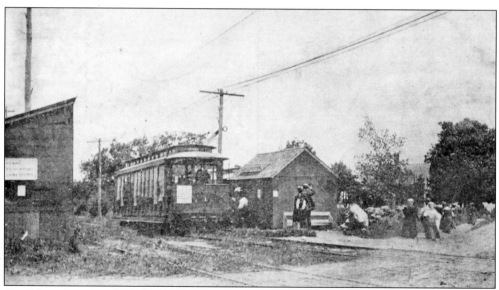

Sea View Station, Saunderstown. A popular summertime convenience, the trolley was extended into Wakefield and Peace Dale in 1902. The early years were the trolley's best and most prosperous times. However, by 1920, it had fallen on financial hard times and went out of business.

South Pier with Steamer *H.S. Caswell*, *c.* 1870. Known for many years as Tuckers Dock, the old breakwater and dock remained essentially intact until the 1938 hurricane. Steamers like the *Caswell* were put into ferry service carrying visitors four times per day from Newport.

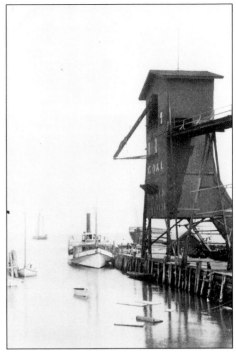

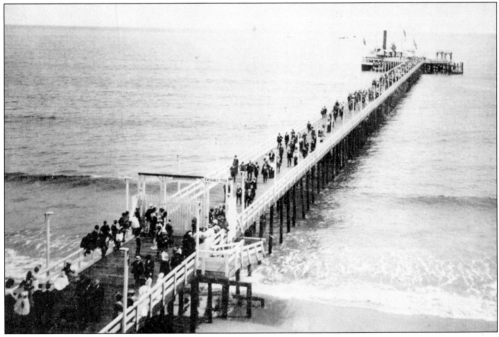

Steamboat Landing. Constructed in 1897, the new pier was located on the beach south of the Dunes Club. It was designed to handle the larger steamships carrying passengers from Providence and New York. The merry-go-round at the end of the pier delighted children. Built by the Providence, Fall River and Newport Steamboat Company, it was 1,100 feet long and extended to a water depth of 16 feet. Time and weather have reduced this structure to a few old pilings that can be seen at low tide.

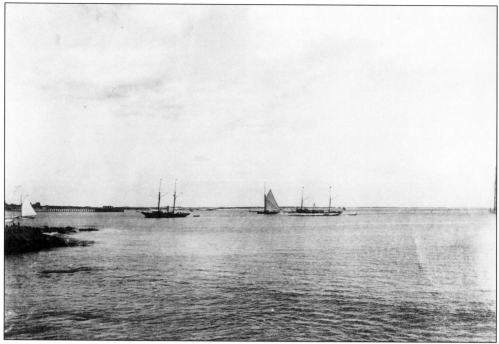

Narragansett Waterfront, c. 1890. Both sailing and steam yachts intermingle in the waters between South and North piers. Both forms of yachting were used by the wealthy to travel from New York, Newport, and other Northeastern sea ports. The yachts could land at either pier or shuttle their passengers ashore in dinghies.

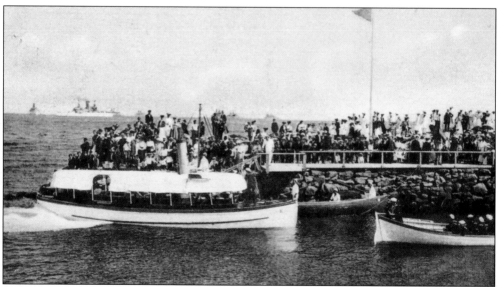

Viewing the North Atlantic Squadron from North Pier. The U.S. Navy visited many important locations in this country, as well as throughout the world. Dubbed the "white fleet," the visiting ships offered Narragansett residents who were invited to board the warships (seen offshore) a ride in the captain's launch.

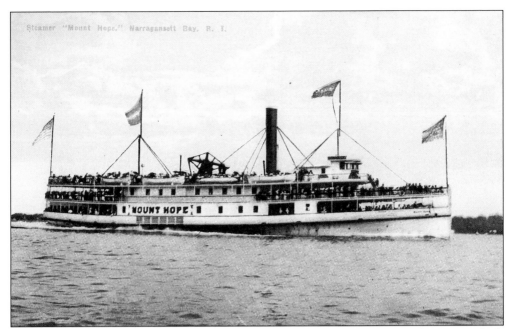

Steamer "Mount Hope," Narragansett Bay. R. I.

Steamer *Mount Hope, c.* 1897. This side-wheeler was a favorite observational steamer which made regular runs between Providence, Newport, Narragansett Pier, and Block Island. Fueled by wood in their early years, more efficient coal-powered engines soon extended the steamers' range and capacity.

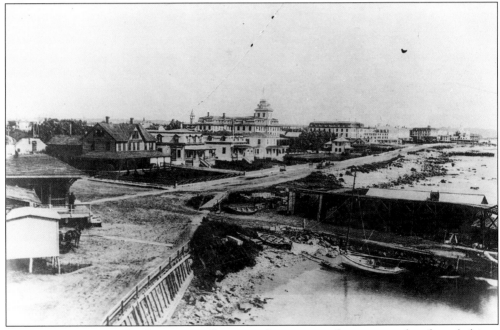

South Pier, *c.* 1884. This busy scene illustrates the amount of commerce that funneled into Narragansett by land and by sea during the latter part of the nineteenth century. The NPRR Station can be seen at the left edge of the photograph.

33

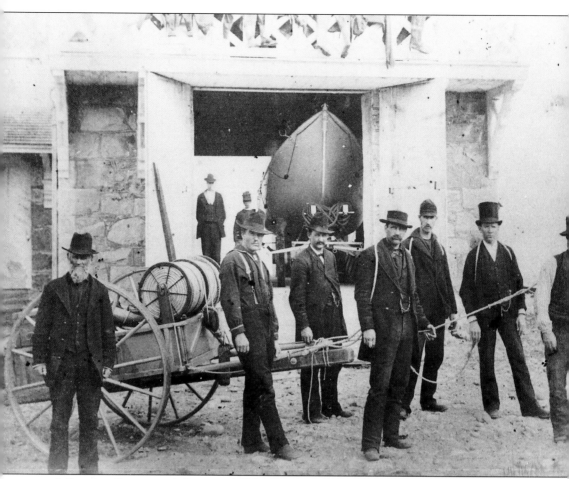

Lifesaving Station and Crew, *c.* 1876. This station was established in 1876 on Narragansett Beach near the present site of the Dunes Club. Surf boats and equipment were stored on the first floor; crew quarters were located above in the second story. Pictured from left to right are Captain Benjamin Macomber, Daniel Billington, Horace Briggs, Terry Ralph, Thomas Sennett, Joshua F. Clarke, and William C. Chappell. Pictured with the crew is a "breech's buoy" which was used with a "lyle gun" to secure a lifeline to stranded vessels. The system had a 1/4-mile range, and crews would practice the technique to achieve two-minute response times. When the Life Saving Service merged with the Coast Guard in 1915, this system of rescue was maintained until the 1960s. In 1887, the Life Saving Crews of the Third District (Rhode Island and Long Island Sound) rescued "2,040 people from wrecks without the loss of a single life; a record that will probably never be equaled" (*Rhode Island: Genealogy-Biography, Vol. II*, 1908). The list of shipwrecks where crews from the District rendered assistance totals over five hundred, which attests to the high volume of maritime traffic and operating conditions in the nineteenth and early twentieth centuries. The Lifesaving Station on the beach was abandoned in 1888 when a new station was completed near the Narragansett Casino and Towers.

Three

Hotels

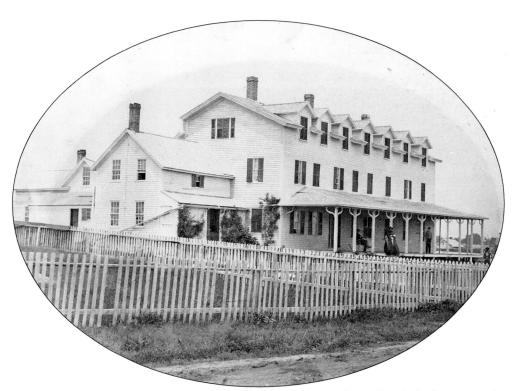

The Narragansett House. Built in 1856 by Esbon S. Taylor on Ocean Road, the house was the first real structure dedicated to an uncertain enterprise—tourism. The first registered guests at the Pier included the Dulles, Lapsley, Randolph, Welch, and Strang families. Enlarged in 1867, it was a very successful hotel until sold and removed from the site to Congdon Street in 1888.

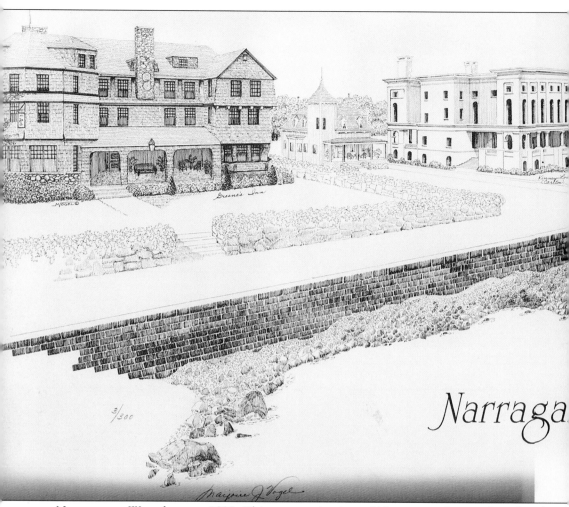

Narragansett Waterfront, c. 1898. This panoramic view of Narragansett's waterfront hotels was created by artist Marjorie J. Vogel. By the end of the nineteenth century, the hotels had reached their zenith in number and size. Visible in this graphic, from left to right, are the Greene's Inn, Kinney Lodge (Carlton), Imperial, Continental, Revere House, Atwood, Atlantic, Mathewson, and the Rockingham (behind Mathewson). Other prominent hotels not visible in this perspective include the Gladstone, Massasoit, Tower Hill House, Metatoxet, Ocean House, and the Pettaquamscutt. Smaller family hotels such as Chandlers, Clarkes, Sea View, and the Mansion House were also doing a brisk business. Most of the hotels were built by local residents who started out by adding on to their boarding houses, or building new structures that could be expanded with extra floors or wings.

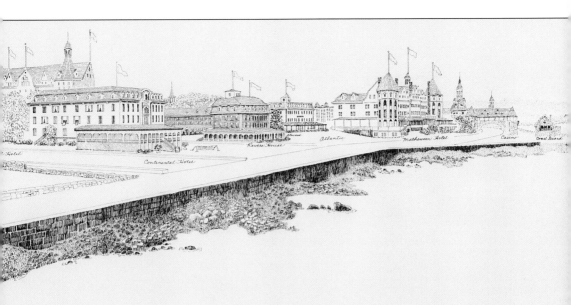

tt Pier, Rhode Island

Historic Hotels
circa 1898

The growth of great wooden hotels in Narragansett signaled its arrival as a popular seaside resort. The scramble for business led to quick turnovers among proprietors and hotels alike: "The hotels were as changing as the sands on the beach. A structure would be erected and used a season or two, then its name changed, would open under new management. Or perhaps the entire building would be moved to a new location, or joined to another structure and the two open under a new name. Still others would be razed after several years' use, and on the site would be built a new and more modern hotel" (*American History Illustrated: Summering at the Pier*, 1978). Each of the hotels developed a certain character or social flavor and thus attracted a certain clientele who would faithfully return year after year.

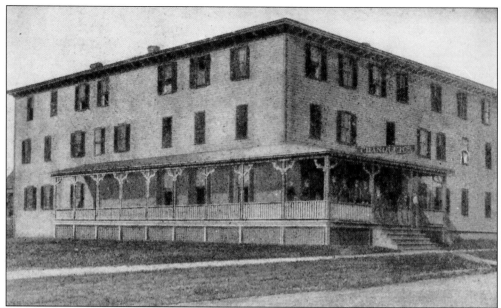

Chandler's, *c.* 1891. Originally called the Narragansett House (1856), it was moved from its site on Ocean Road in 1888 to the south side of Congdon Street. It was later renamed the Ormsbee, then the Highland, and finally the Bay View. Serving as a rooming house and bar in its later years, the first hotel in Narragansett became one of the last when it was torn down in 1967.

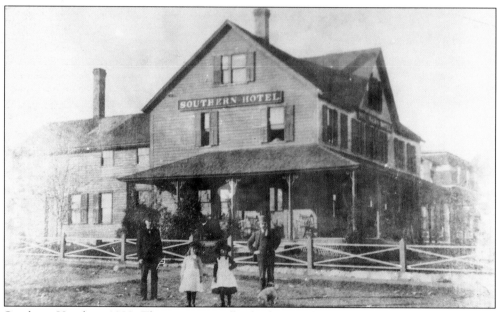

Southern Hotel, *c.* 1880. This was originally the home of W.E.H. Whaley, who was one of the first residents to take boarders at the Pier. Mr. Whaley enlarged his home and called it the Whaley House. In 1880, it was purchased, remodeled, and named the Southern by H.W. Greene. It made no pretensions to vie with its larger neighbors, but was always full in the summer.

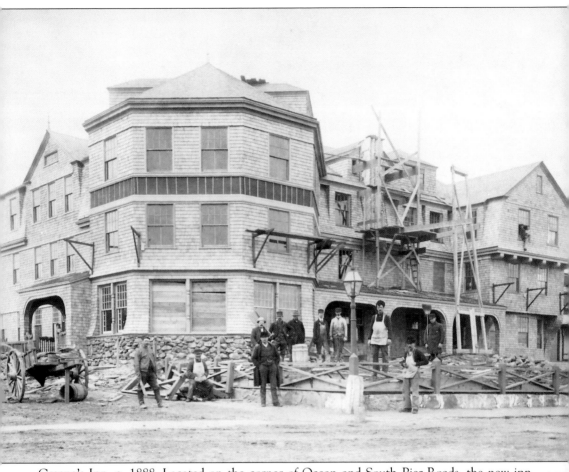

Greene's Inn, c. 1888. Located on the corner of Ocean and South Pier Roads, the new inn occupied the site of the old Southern Hotel. Built after the English style of architecture, this lovely inn was different than other hotels at the Pier. Designed to "produce a hostelry, promising creature comforts found in English country inns" (*American Architect and Building News*, 1888), Greene's Inn provided steam heat in the rooms and was intended as a year-round hotel. The workmen in the photograph have taken time out from the nearly completed structure for a picture. A large livery and boarding stable was constructed behind the inn. More than a hundred polo ponies would be quartered there during the polo season. Many Narragansett residents will remember the lobby at the inn which contained a beautiful telephone booth, reportedly one of the first in America.

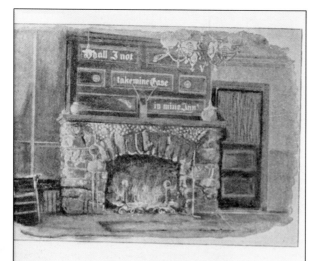

GREENE'S INN

OPEN THE ENTIRE YEAR. **NARRAGANSETT PIER.**

THIS INN is designed to supply a recognized want here, viz.: "a good all-the-year-round house," equally adapted to summer and winter requirements. The house was designed with the intention of producing a hostelry that would furnish some of the creature comforts so commonly found in some of the English inns, and which some of the great caravansaries lining our coast are the furthest possible from securing.

The house is strictly first-class in all its appointments; heated by steam as well as open fires, with ample bath and toilet accommodations;

Greene's Inn Fireplace. This inn will be remembered by many as a beautiful, gracious structure with charming public rooms. The fireplace in the lobby was reflective of the style of the late 1800s, and when the inn burned in 1980, the decorative stone above the fireplace was salvaged and incorporated into the stone wall at the corner of Ocean and South Pier Roads.

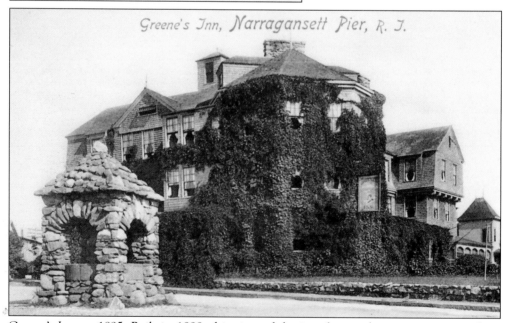

Greene's Inn, *c.* 1895. Built in 1888, this view of the inn shows a horse-watering trough in the road. A unique stone structure, the trough was a welcome convenience provided by the Wakefield Water Company. Under the direction of several different owners, the inn continued to cater to both out-of-town and local patrons until 1980, when it was destroyed by fire.

Mount Hope Hotel. Built in 1871 by William G. Caswell on the corner of Ocean Road and Congdon Street, the hotel was subsequently enlarged to accommodate three hundred guests. The main office of Western Union was located in the hotel, which enjoyed great popularity for many years. In 1889, Edward Earl purchased the property and changed its name to the Berwick. Mr. F.S. Kinney purchased the property in 1894 and razed the wooden hotel to make room for his private residence.

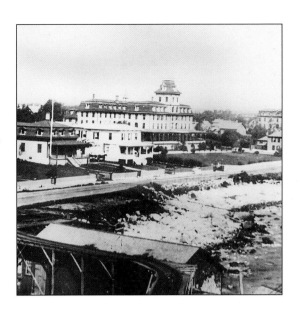

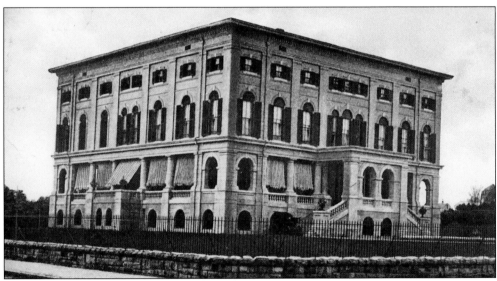

Carlton Hotel (Kinney Lodge), c. 1895. Built by F.S. Kinney, maker of one of America's first cigarettes, as a private residence on the site of the Mount Hope Hotel, the house was used as a summer home until its owner's death. The property was then purchased and remodeled to function as a hotel. Its unique construction proved durable, and the hotel was in operation until 1968 when it was torn down. This oceanview property is now a vacant lot.

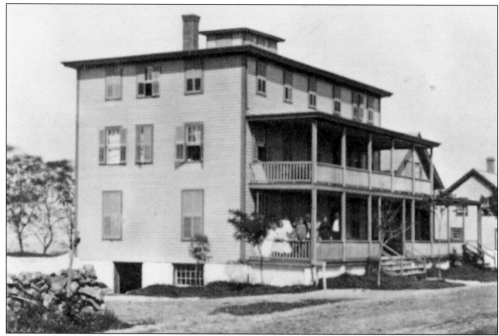

The Sea View. Built in 1860 by John Eslick on Kingstown Road near the site now occupied by the Narragansett Pier Library, this early guest house changed very little over the succeeding years and became a reminder of old Narragansett by serving as a rooming house and small store until the 1960s.

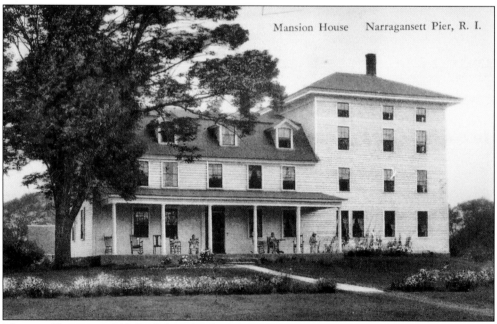

Mansion House, c. 1866. Built by Abijah Browning as an addition to the Watson farmhouse, this structure reflects the local response to the ever-increasing summer population's requests for rooms. It was located on what is now Mansion Avenue between Kingstown Road and Narragansett Avenue.

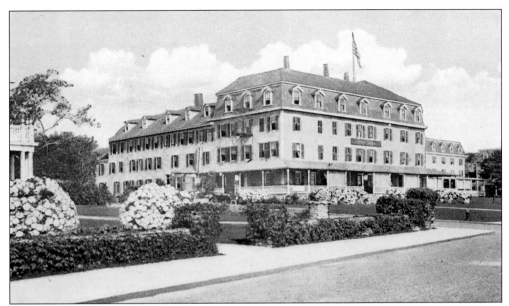

Revere House. Built in 1868 by Capt. James H. Rodman, the Revere was located on the corner of Ocean Road and Rodman Street. Rodman was one of the first to build a house at the pier for the purpose of taking boarders. His original house (1855) formed a part of the hotel, which had a capacity of one hundred and fifty guests. For many years the house was known as a center for New York society people. It was destroyed by fire in 1928.

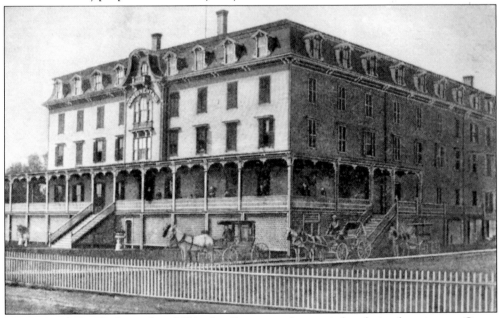

Continental Hotel. Opened in 1871, the Continental occupied a choice location on Ocean Road between Congdon and Rodman Streets. The Continental could accommodate nearly two hundred guests. "At the time of its construction, it was probably the best built hotel in Narragansett" (*Memories of Narragansett Pier*, W.H. Taylor, 1920). In 1905, it was sold for $3,000, moved to Beach Street, and renamed the Burnside, which later became the Hotel De La Plage.

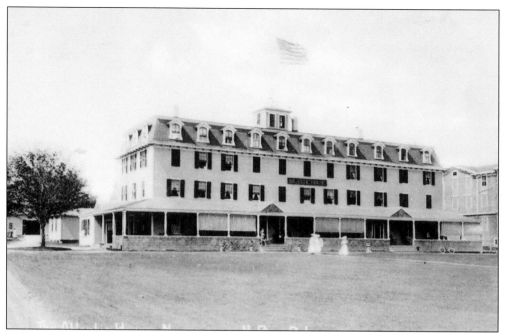

Atlantic House. Opened in 1867 by Abijah Browning, this structure was located on Ocean Road at the present location of the Atlantic. Always a popular hotel in an ideal location, it has experienced several major modifications, but remains today the only residual of the nineteenth-century hotels in Narragansett.

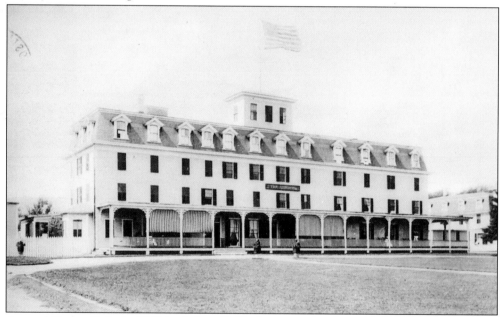

Atwood House. Built in 1867 by Joshua C. Tucker immediately south of the Atlantic House on Ocean Road, it was later enlarged to accommodate two hundred guests. The house was 130 feet long with a wide lawn fronting the ocean. A virtual twin to its neighbor (the Atlantic House), it was later renamed the Breakers. By the 1960s, it was empty and silent and was torn down in 1967.

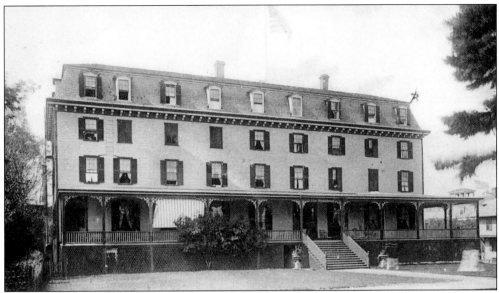

Massasoit Hotel. Constructed in 1870 on Narragansett Avenue for Edward Tucker, the hotel was originally named the Maxson House. An unsuccessful enterprise, it was taken over by the bank and moved in 1877 to Mathewson Street and renamed the Massasoit. Enlarged to accommodate one hundred and forty guests, it provided an excellent view of the ocean and Casino buildings and grounds. One of the more successful hotels, it remained open until 1971 when it was destroyed by fire.

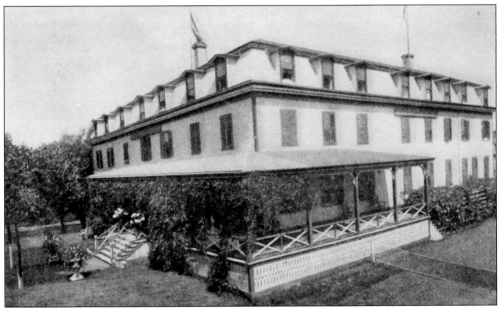

The Columbus. Originally built by John L. Hazard in 1870 on Narragansett Avenue, the hotel was known as the Hazard House. Purchased by Walter Nye in 1879, it was moved to Central Street, remodeled to accommodate one hundred guests, and renamed the Columbus. After several years of successful operation, Mr. Nye moved it to the back of the lot and incorporated it into his new Imperial Hotel.

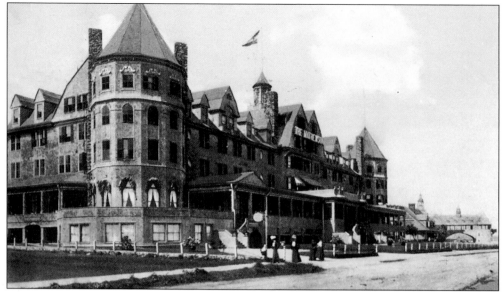

The Mathewson Hotel, *c.* 1898. One of the best known of Narragansett's hotels, the Mathewson was originally built in 1868 on Ocean Road between Taylor and Central Streets. Enlarged several times, it could accommodate up to five hundred guests. It was considered one of Narragansett's leading hotels in its day. Even though it was able to achieve a unique architectural identity, it eventually succumbed like the other large Pier hotels and was auctioned off and torn down in 1919.

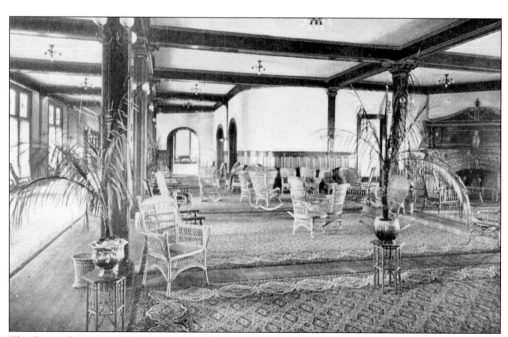

The Rotunda, *c.* 1898. Upon entering the Mathewson, visitors were impressed with the amount of space devoted to public places and the attractive and comfortable surroundings.

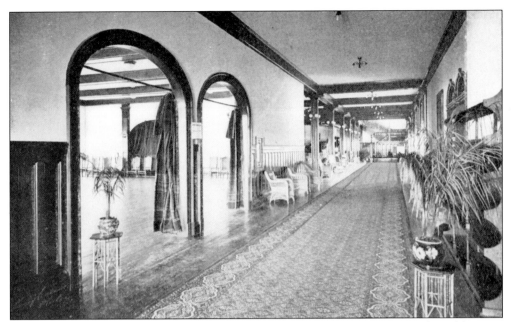

The Mathewson's Main Hallway, c. 1898. The main hallway provided access to the public areas on the first floor, as well as the private rooms on the upper floors. Measuring 50-by-75 feet and facing the ocean, the ballroom (to the left) was the place where dances, concerts, and other events were regularly held.

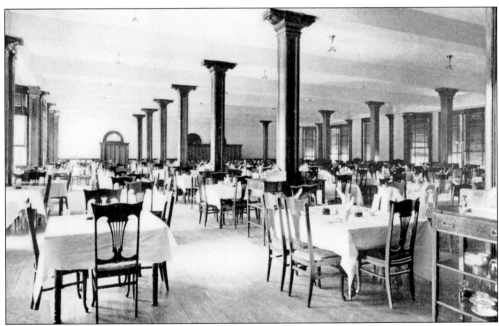

Dining Room, c. 1898. The Mathewson was known for years for its famous cuisine. The hotel would bring in well-known chefs from New York to pamper the palates of their summer guests, and it became a favorite of food connoisseurs.

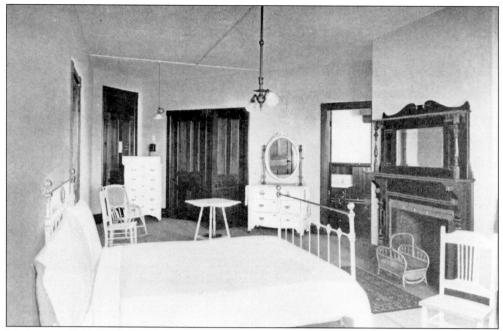

Mathewson Front Bedroom, *c.* 1898. Spartan by today's standards, this room is 15-by-36 feet in size. The windows look out over the ocean and the Narragansett Casino. Screens were included to keep out mosquitoes, and electricity was added in the 1890s. An entrance to a private bath is shown to the left of the fireplace.

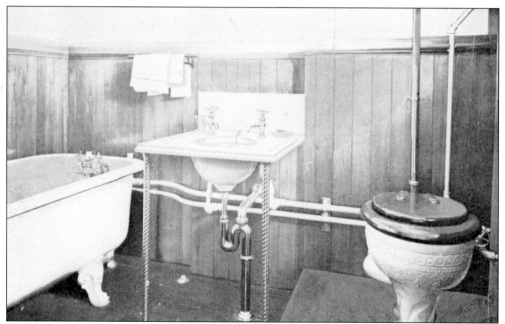

Private Bathroom, *c.* 1898. Modern and elegant for its day, this bathroom at the Mathewson featured a large claw-foot tub and ornate commode. Some bathrooms were plumbed for hot and cold, fresh and sea water.

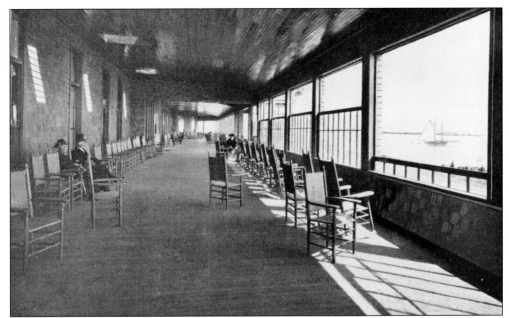

Mathewson Front Piazza, c. 1898. Overlooking the ocean, this piazza was 1/7 mile long and 23 feet wide—perhaps the widest of any hotel. An innovative feature included pocket windows that could be raised at a moment's notice to keep out inclement weather.

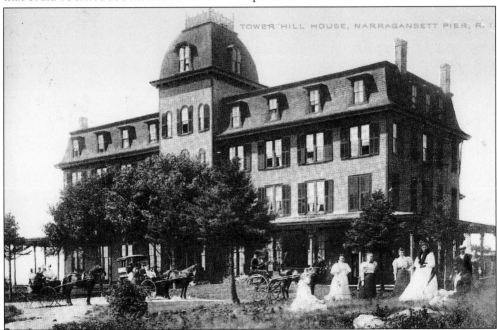

Tower Hill House. This hotel opened in 1871 on the site of Tower Hill Village about 1 mile west of Narragansett Beach. It commanded a view from Newport to Block Island, could accommodate two hundred and fifty guests, was surrounded by 30 acres of lawn and shade trees, and included a "horse railroad" to the beach. Closed in 1892, it was taken over by the Catholic Diocese of Providence. A summer camp was established on the property in 1907 for urban youth. Today, the Monsignor Clarke School occupies the site.

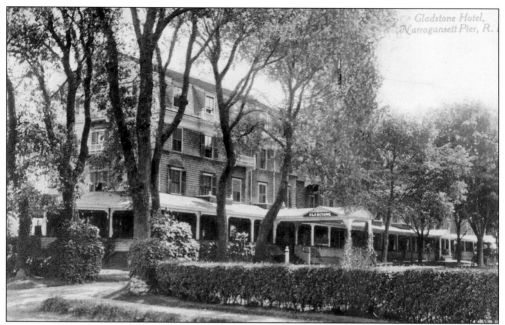

The Gladstone Hotel. Built in 1887 by George C. Robinson, it was located on Kingstown Road where the Narragansett Pier Townhouse Condominiums now stand. The core structure was made by combining the Delavan and Elmwood Hotels. It could accommodate three hundred and fifty guests and had 500 feet of piazzas overlooking beautiful lawns and shade trees. The Gladstone, like the other large hotels, fell into decline and was torn down in 1920.

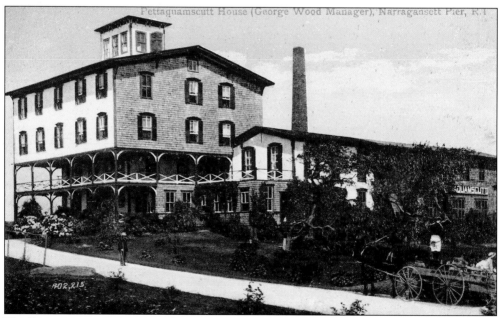

The Pettaquamscutt House. Built in 1885 by Capt. George N. Kenyon on 150 acres known as Little Neck Farm, this unusual hotel had unobstructed views of the beach and Pettaquamscutt River. The site is near the present Starr Drive West and is occupied by a number of private homes. The hotel operated until 1920 when it was sold and torn down.

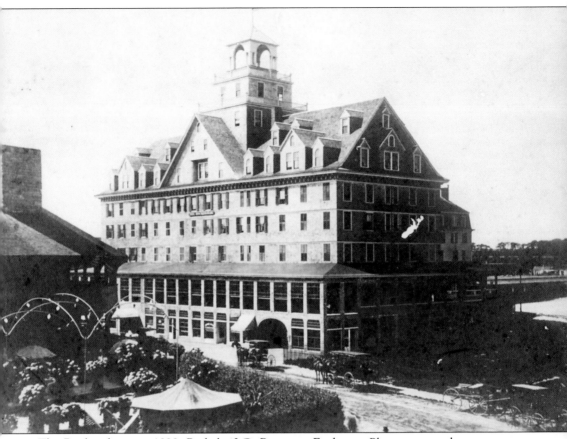

The Rockingham, *c.* 1898. Built by J.G. Burns on Exchange Place next to the present post office, the hotel was called the McSparran in 1883. It was enlarged several times becoming "the largest, safest, newest, most commodious and elegantly appointed hotel of those among the New England summer resorts" (*New Rockingham Hotel Souvenir Booklet*, 1898). Broad piazzas fronted on the ocean, the bathing beach, and overlooked the famous Narragansett Casino directly across the street. The hotel was lighted by electricity and featured hot and cold seawater and freshwater baths in one hundred and fifty rooms. Public rooms including parlors, reading rooms, and the grand stairway opened out of a large, 120-by-50 foot main lobby. The ballroom "is one of the most charming of the public rooms, being decorated in white and gold. It opens by arches, into the lobby, thus utilizing the grand lobby as a promenade for the dancers and guests" (*Ibid.*). An orchestra was provided throughout the season and daily concerts were held. All of this came to a sudden and tragic end in September 1900, when a fire started on the top floor and destroyed not only the hotel but also the Narragansett Casino and a number of other buildings in the downtown area of the Pier.

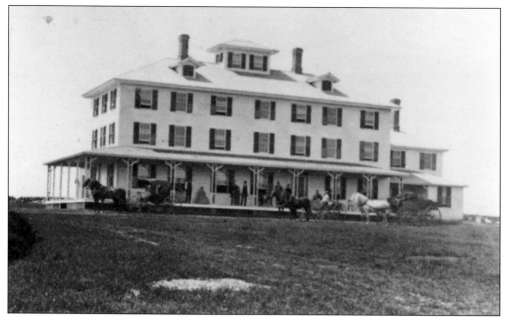

Metatoxet Hotel, c. 1870. Built by John H. Caswell in 1866–67, the Metatoxet was one of the early family hotels at the Pier and at that time had only twenty-nine rooms. Enlarged several times to a capacity of one hundred and fifty guests, the hotel was set back 300 feet from Kingstown Road by a large elegant lawn and ample shade trees. It was renamed the Beachwood in 1920 but a fire in 1958 destoyed the hotel. The Beachwood Apartments now stand on the site.

Elizabeth Brown Wood, c. 1900. The center figure in the picture, Elizabeth was the daughter of Peleg Brown. To the right is George E. Wood, her husband, who helped to operate the Pettaquamscutt Hotel from 1891 to 1920. Mrs. Wood, whose life became the hotel business, purchased the Metatoxet Hotel in 1920, renamed it the Beachwood, and ran a fine hotel until 1936, when she retired from the business.

Delavan House. Built by David Briggs in 1869–70 on the corner of Kingstown Road and Mathewson, the Delavan could accommodate one hundred guests and was very popular with the military crowd. The upper rooms had a fine view of the Narragansett Casino and tennis courts. Adjacent to the Delavan was the Elmwood which was built by Mr. J.G. Peckham in 1869 on land occupied by the cottage of Benjamin Hadwin, who had taken in some of the Pier's first boarders in 1845. The Delavan was later moved and combined with the Elmwood to form the core structure of the Gladstone.

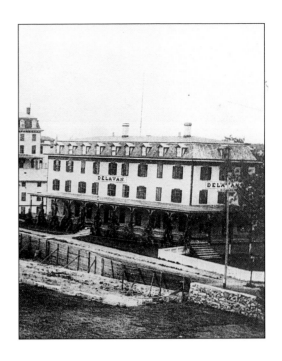

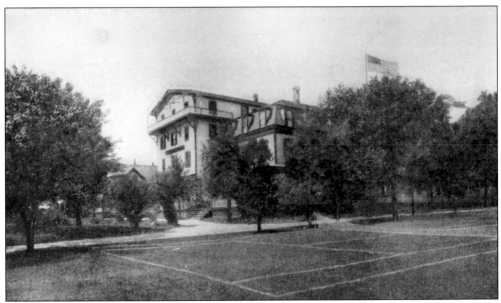

Ocean House. Built in 1869–70 for Mrs. S.L. Reed on Caswell Street between Central and Kingstown Road, the Ocean House was typical of the hotels that were built and operated by local families. A favorite hotel for families who did not want to locate on the beach, it included such amenities as lawn tennis courts. Renamed the Arlington about 1895, it eventually went out of business in 1917 and was torn down.

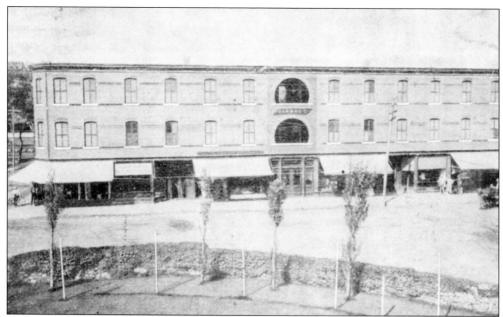

Clarkes. Built by William C. Clarke in 1890, this unusual building was constructed of brick, iron, and stone. It was located on Beach Street at the present site of the Village Inn. The three-story building contained businesses on the ground floor and thirty-eight guest rooms on the upper floors. Later it was named the Ocean View and was destroyed by fire in 1968.

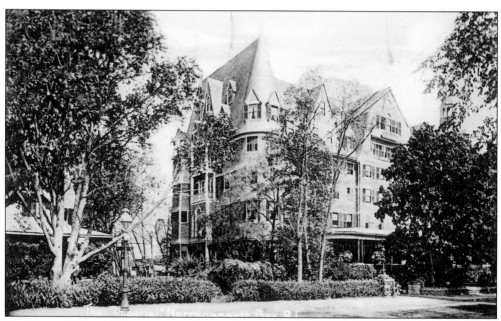

The Imperial Hotel. The newest and most elegant hotel at the Pier, the Imperial was built in 1899 by Walter A. Nye. He had purchased the Columbus Hotel in 1893 and promptly enlarged it. Then in 1898, he moved it to the rear of the lot where it became a part of his distinctive new hotel. It was not the largest, but was the most luxurious and became the summer home of Narragansett's upper strata of society. It was destroyed in a spectacular fire in 1923.

Four

Recreation

Ladies of Leisure, c. 1890. The relaxed informal atmosphere of Narragansett set it apart from other seaside resorts such as Newport. Those who came were no less affluent, but were more conservative and liked their pleasures simple.

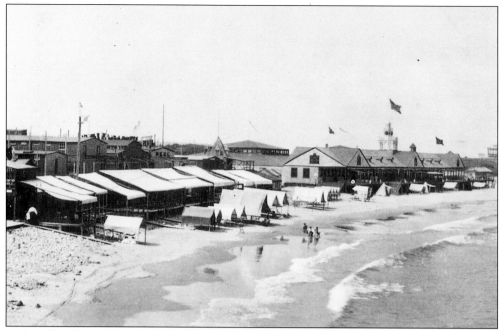

Bathing Beach Looking North to Sherry's, *c.* 1897. "A chief attraction of Narragansett was the bathing beach situated just north of the hotels and extending about a mile in a gentle crescent shaped curve" (*The New England Coast: Narragansett Pier,* 1896). A boat patrolled the beach just beyond the surf line to assist venturesome swimmers.

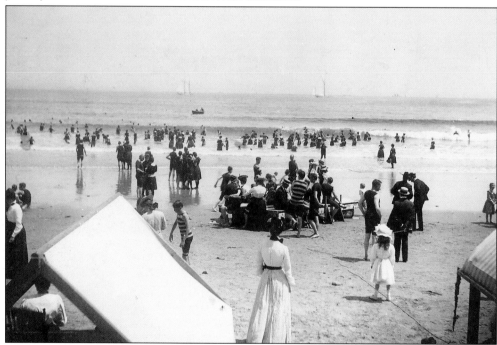

The Bathing Hour, *c.* 1890. The most popular time to "bathe" was between 11 am and 1 pm. At such times there were often over a thousand bathers in the water and double that number watching from the balconies or shelters that fringed the beach.

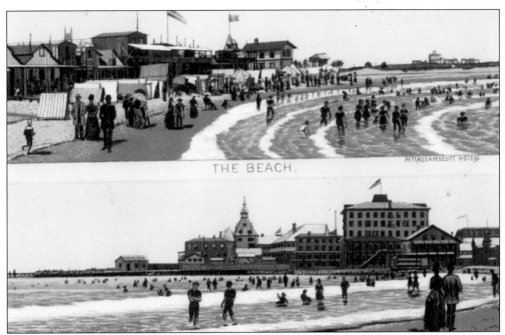

THE BEACH.

PETTAQUAMSCUTT HOTEL

Another Day at the Beach, c. 1900. Chairs, parasols, blankets, and goodie bags all formed part of the daily beach scene. Southern New England's mild climate produced comfortable water temperatures from late June to early September. Fair skies during the summer months cooperated to make Narragansett one of the finest beaches in the northeast.

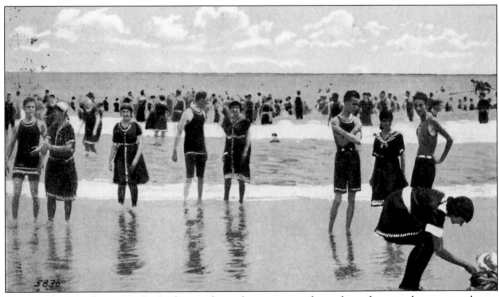

Fun on the Beach, c. 1895. "Ladies and gentlemen came from their dressing houses to plunge into the surf and then danced around playing practical jokes, and seemingly having just the best time allowed to mortals!"(*Narragansett Pier and How to See It*, 1875).

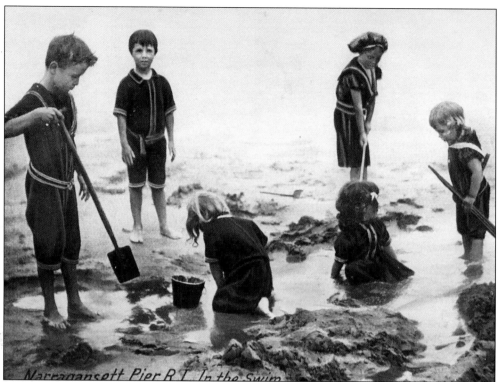

Children at the Beach, c. 1890. The magic of the beach has always attracted children. Sand castles and moats and things that wiggle or float can keep little ones occupied for hours. Here a group of children share in carefree fun of the beach.

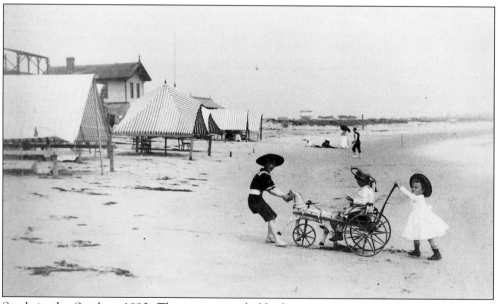

Stuck in the Sand, c. 1890. The interesting hobby-horse cart is an insight to the kinds of playthings available for children at that time. Tent canopies (visible on the left) were a practical shelter from the hot midday sun.

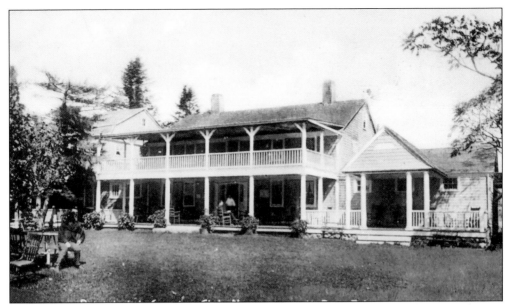

Point Judith Country Club (NRHP), *c.* 1894. A plain farmhouse was used as the clubhouse when Philip S.P. Randolph Sr. and about twenty-five other summer residents established the country club. Mr. Randolph's farm, which ran from Ocean Road to Point Judith Road, was developed into a golf course, polo fields, and tennis courts. Today, the club remains a very well-known, prestigious organization.

Ready for a Round of Golf, *c.* 1895. A nine-hole golf course was established at Point Judith Country Club shortly after its founding. Later the course was expanded to eighteen holes, and it still offers a very beautiful golfing experience. This photograph is indicative of the social standing of the sport in the nineteenth century.

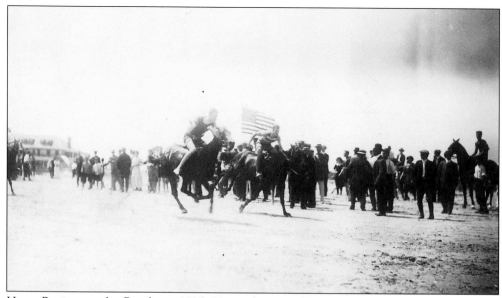

Horse Racing on the Beach, c. 1895. Horse shows and horse racing became regular events after the establishment of the Point Judith Polo Club. Sporting horsemen from as far away as Virginia would ship their best mounts to Narragansett to compete on the beach. Betting was brisk and competition keen.

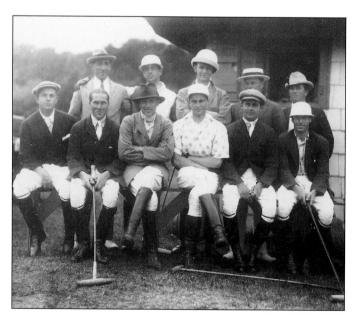

Point Judith Polo Team, c. 1900. Philip S.P. Randolph Sr., founder of the club, is in the second row, second from the right. Many well-known teams of the day, including British, Indian, and the U.S. cavalry teams, played at Point Judith. Polo went out of style with the eve of World War II. The old polo fields are no longer evident.

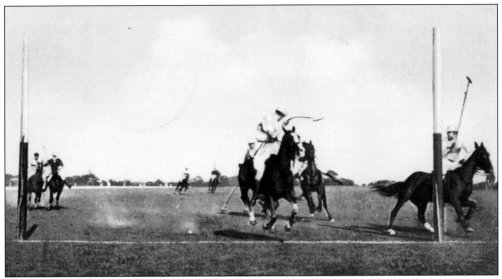

Polo at Point Judith Club, c. 1895. The Point Judith Polo Club joined the U.S. Polo Association in 1895 and began to attract polo teams from around the world. Polo ponies were transported by train from the main line at Kingston by the Narragansett Pier Railroad. Three polo fields were maintained at Point Judith Country Club where national and international tournaments were played in August.

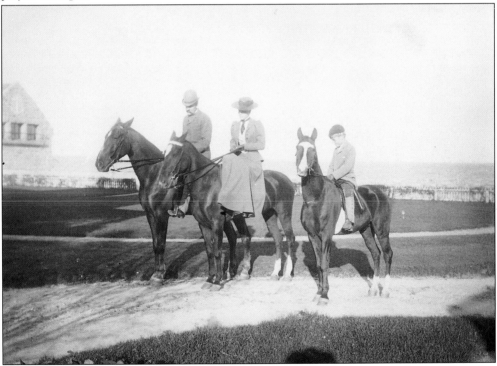

Hitchcock Family Outing on Horseback, c. 1898. Horsemanship was a valued skill in this affluent society. The miles of scenic roads and trails in Narragansett were a special treat to families from large cities such as New York, Philadelphia, and Baltimore. Lifesaving Station is on the left of the photograph.

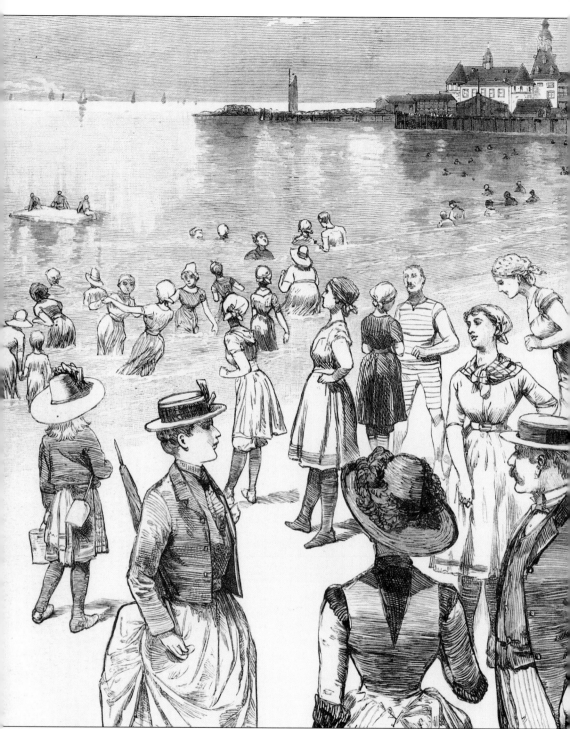

Summer Life at Narragansett Pier. *Frank Leslie's Illustrated Newspaper* dated July 30, 1887, was widely circulated. Other publications such as *Harper's* and *Leisure* also ran feature articles about Narragansett. This type of publicity helped to create steady growth. "Year by year a larger number of people are flocking seaward to breathe the pure ozone-laden air wafted landward from

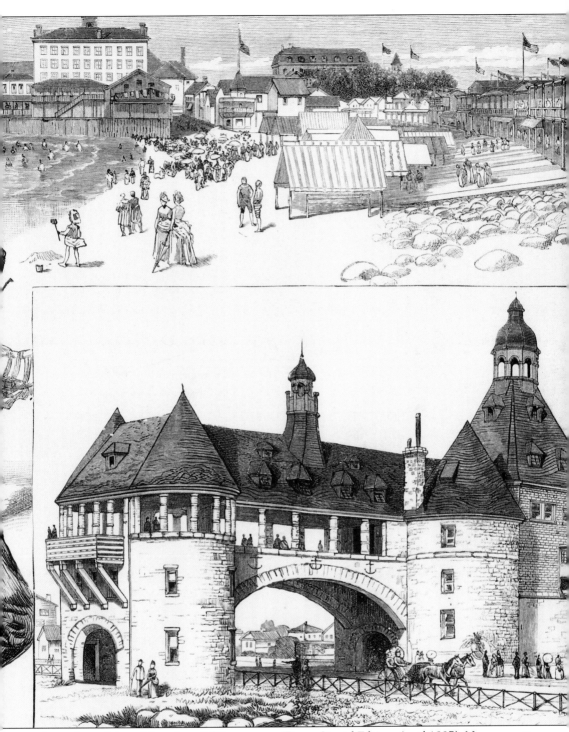

the surface of the mighty ocean" (*Narragansett Times: Special Edition*, April 1887). Narragansett was, however, among the least advertised and pushed of any of the seaside resorts along the Atlantic coast. "It never has assumed greatness; rather it has had greatness (i.e. popularity) thrust upon it" (*Ibid.*).

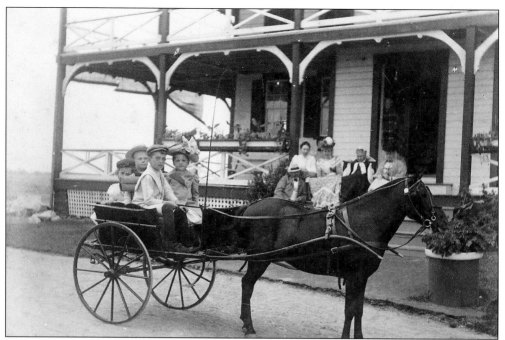

A Pony Cart for the Children, c. 1895. Local stables maintained a variety of livery for any occasion. These fun-loving children might be on their way to the beach or the Narragansett Casino, or just a drive to the countryside.

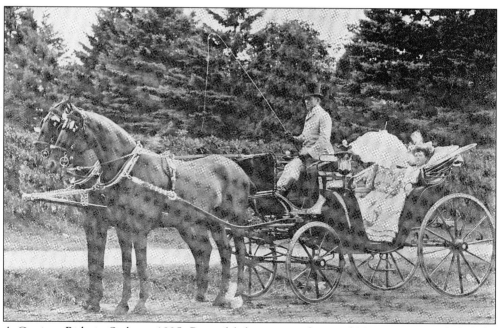

A Carriage Ride in Style, c. 1895. Beautiful drives in and around Narragansett included the ocean front, from the Narragansett Casino 5 miles to Point Judith; and a drive along the Pettaquamscutt, past Canonchet and northward 8 miles through the countryside to Gilbert Stuart's birthplace.

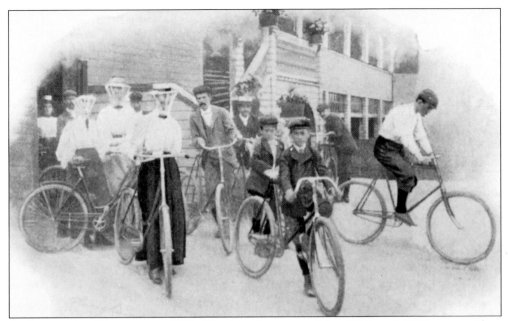

Cycling in the Afternoon, c. 1897. The bicycle vogue of the 1880s and 1890s was evident in Narragansett. Bicycles were available for rent through the larger hotels. Increasing numbers and the conduct of cyclists raised issues of rights of way and created annoyances with pedestrians and horsemen. However, cycling was here to stay. In 1880, the League of American Wheelmen was organized in Newport, and in a few years there were more than thirty clubs in Rhode Island. One cycling club in Philadelphia made a cross-country tour to Narragansett—300 miles in five days.

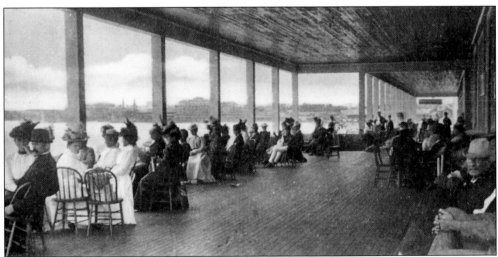

People Watching from Sherry's Bathing Pavilion, c. 1895. The broad spacious pavilion at Sherry's near the center of the beach, complete with restaurant, bathhouses, and shops, was also a favorite location for those who preferred to watch rather than participate in the bathing ritual. After a fire in 1896, Sherry rebuilt and added a bicycle rink with a hundred rental bikes. Band music and dancing made Sherry's a lively and popular place on the beach.

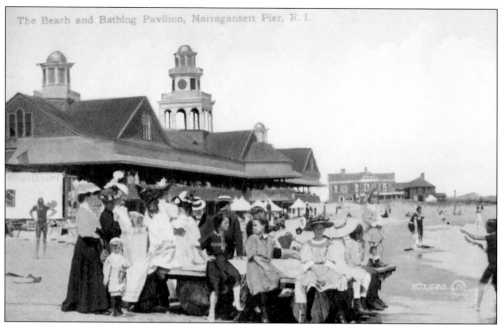

Hanging around the Raft, c. 1895. The gently sloping beach, soft clean sand, and the absence of seaweed created a perfect bathing beach. The use of swimmers' platforms that could be anchored beyond the surf line enhanced the pleasure and safety of bathers.

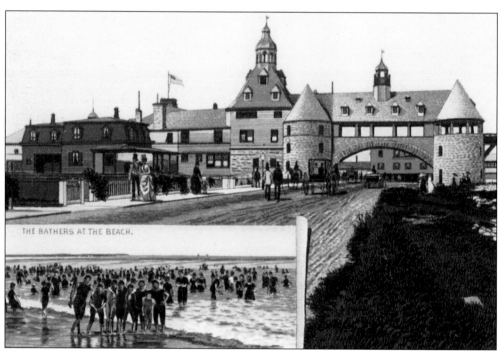

THE BATHERS AT THE BEACH.

The Favorite Attractions, c. 1890. This image from a souvenir booklet highlights the favorite attractions of Narragansett. The beach and the Casino were important elements of the daily rituals practiced by most summer guests.

Five

Narragansett Casino

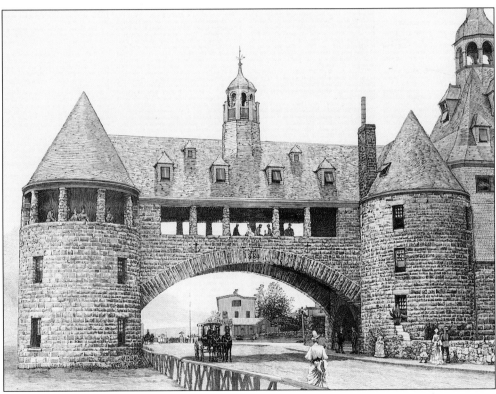

The Casino Towers (NRHP), c. 1887. In 1883, a group of influential Narragansett businessmen and summer residents organized the Narragansett Casino Corporation "for the purpose of using, promoting and enjoying games and sport of every kind, and for the development and improvement of literary and social intercourse and physical and mental cultivation of its members" (*The Narragansett Pier Towers and Casino: 100th Anniversary*, 1983).

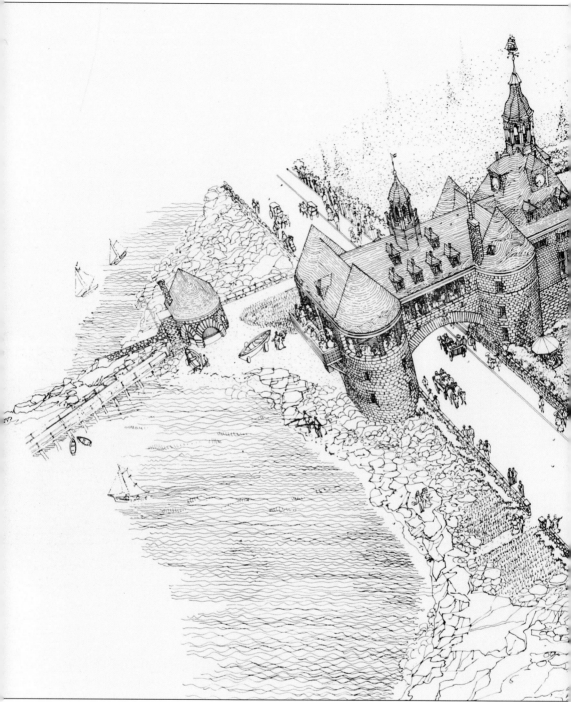

Narragansett Casino, c. 1898. This impressive architectural rendering was prepared by Gary Irish Graphics. It provides a perspective of the casino that is not available through photographs. Designed by McKim, Mead and White, the Casino was striking in appearance and unlike any other building ever constructed. The building and grounds extended from Ocean Road to Mathewson Street. A massive 50-foot stone arch connecting double towers spanned the road

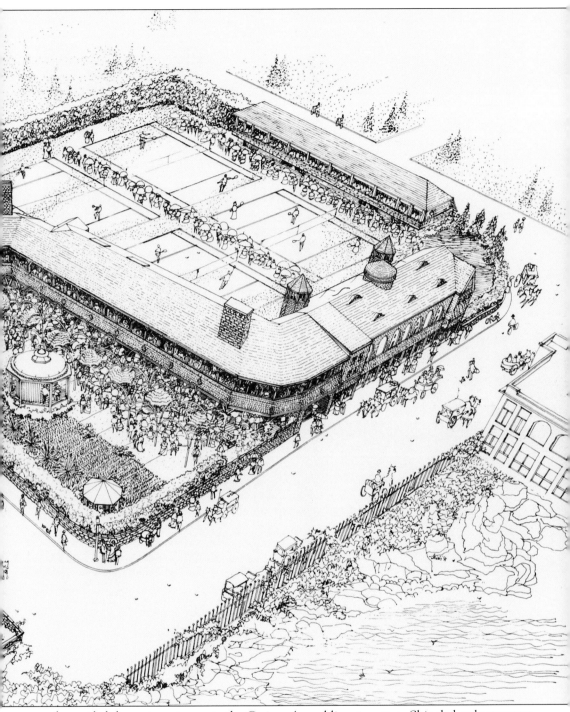

and provided the main entrance to the Casino. A rambling, two-story Shingled-style structure which swept out over the grounds in an S shape, the building contained a variety of rooms, halls, shops, and promenades. The Casino was a favorite among attractions at the Pier and was certainly the center of social life for the summer colony.

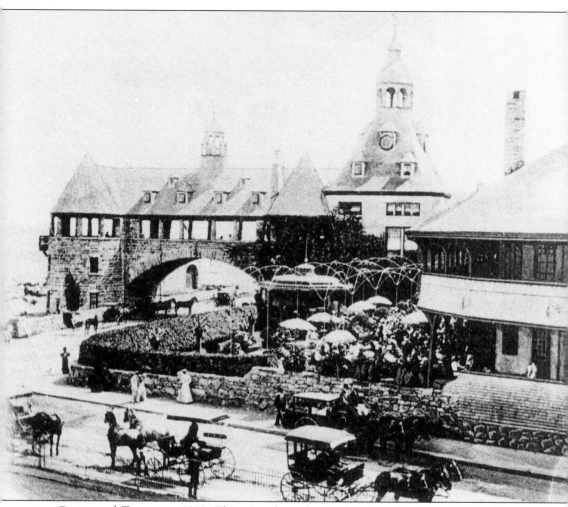

Casino and Towers, c. 1899. This view from the Rockingham Hotel shows the Casino and grounds fully developed. The dining terrace has been expanded and enclosed with stone walls and a privy hedge. The dining hall was adjacent to the terrace, and both the promenade and the terraces in front were often covered with lunch and dining parties overflowing from the hall. Also visible is the bandstand where the best musicians were employed to serenade crowds in the afternoon and evenings. Just visible to the right of the picture is the circular rotunda with a huge stone fireplace and overlooking balcony. "Isn't it like a splendid scene at the theatre? It is too romantic to be real" (*Harper's New Monthly Magazine*).

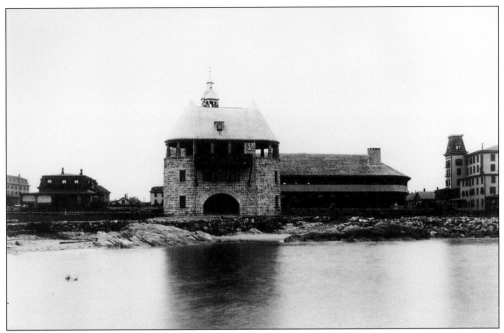

Towers and Casino from the East, *c.* 1887. This unusual photograph taken from the east clearly contrasts the heaviness of the stone towers with the open air promenades, high pitched roofs, dormers, belfries, and lookouts of the casino. Notice that the Lifesaving Station has not been constructed and the Rockingham Hotel has not been expanded.

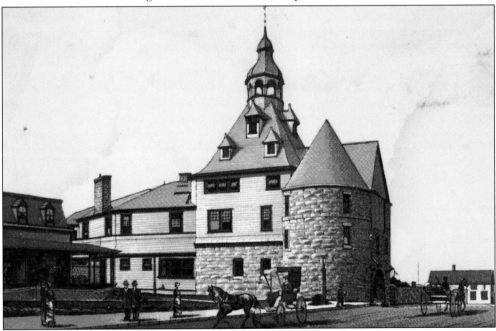

West Tower of the Casino, *c.* 1884. The Casino complex was constructed over a two-and-a-half-year period (1883–1886). The west tower and adjoining leg of the Casino, shown in this picture, were completed in 1884. The arch, east tower, and final leg of the Casino were completed in 1886. The partially completed facility was formally opened in July 1884.

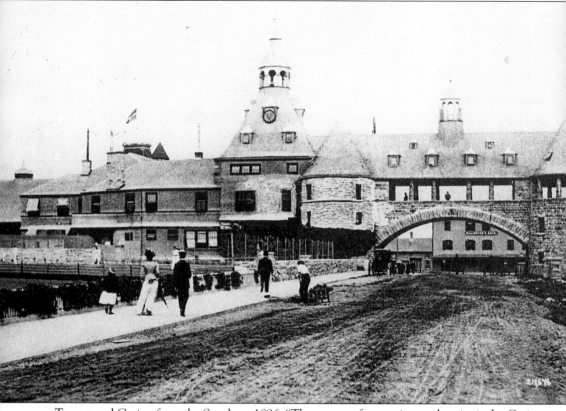

Towers and Casino from the South, *c.* 1896. "The centre of attraction at the pier is the Casino, where all assemble for a morning chat, arrange pleasure parties, meet friends, and indulge in pleasant gossip after a bath in the sea" (*Narragansett Pier Souvenir Booklet*, 1895). From any view the structure was imposing yet inviting. The Casino was the focal point for some five thousand daily visitors during the height of the season in August. "The routine varied little. In the late morning vacationers went to the Casino to read mail, write letters, watch tennis matches and move from one conversational cluster to another" (*Ibid.*). The smaller structure visible under the arch was known as the "Studio," a popular focal point for beach-goers. A seawall along Ocean Road has yet to be constructed.

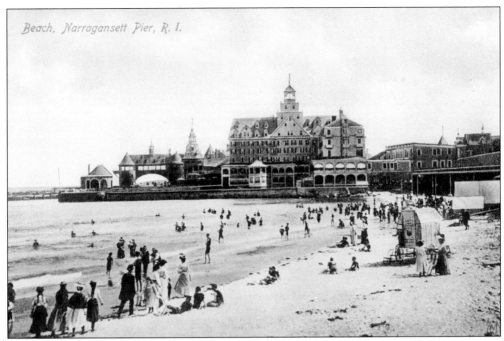

Beach, Narragansett Pier, R. I.

Casino and Towers from the North, c. 1900. This view from the beach shows off the impressive size of the "new" Rockingham Hotel, which had recently been enlarged. The Casino was not a gambling establishment, but a social center for the summer colony. A photographer's cart can be seen on the beach.

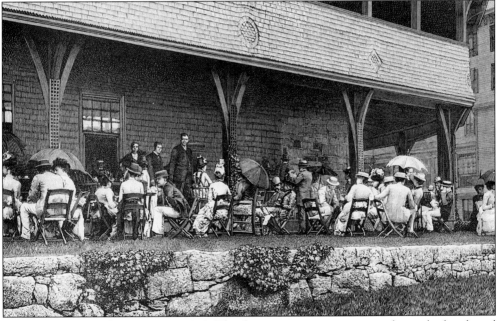

Outdoor Dining at the Casino, c. 1898. The dining terrace was very popular at the lunch and dinner hours. Louis Sherry, the famous New York restaurateur, was hired in 1884 and was so enamored by Narragansett that he became a heavy investor, developer, and eventual owner of the Casino in 1895.

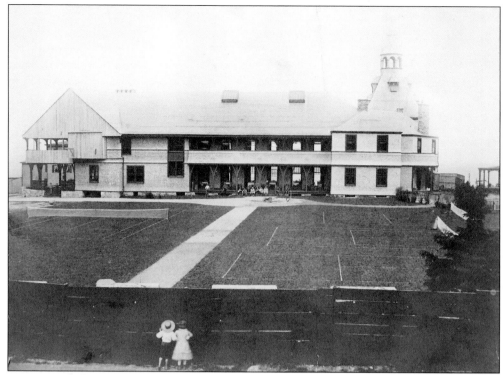

Casino from the West, c. 1884. This rare photograph shows the partially completed Casino from the west. The terrace and balcony, overlooking the tennis courts, joined the main dining hall and billiards room. The casino's massive roof structure and design details are exposed. Even the children were curious about this unusual structure.

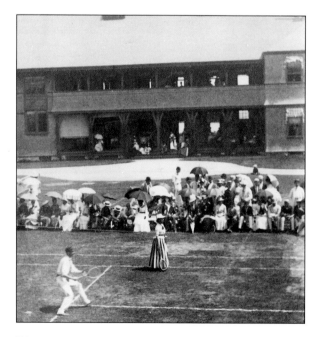

Mixed Doubles Tennis Match, c. 1884. Spectators were seated in chairs or could chose to stand. If the sun was too hot, the shade of the terrace or balcony was available. In 1894, the U.S. Lawn Tennis Association held the Doubles Championship Tournament at the Casino.

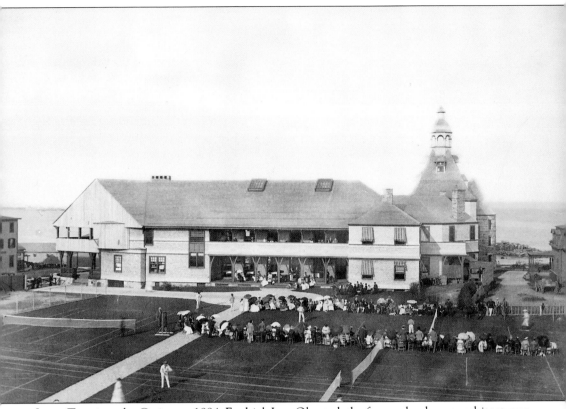

Lawn Tennis at the Casino, *c.* 1884. Fredrick Law Olmsted, the famous landscape architect, was commissioned to design and construct the Casino grounds including the tennis courts. Lawn tennis was a popular new sport and the Casino attracted the "best tennis players in the country" (*Narragansett Times*, August 14, 1893) to tournaments each year. As many as five courts could be accommodated on the spacious grounds.

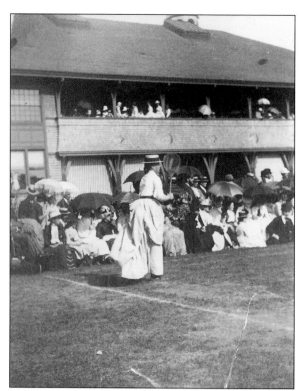

Serving Is Believing, *c.* 1884. In this age of modern tenniswear, its hard for us to believe that serious tennis could actually be played while dressed as the lady is in this photograph. This closer view of the Casino and spectators shows the interesting detail of the decorative shingling.

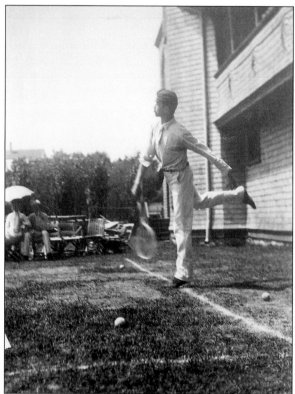

Practice Makes Perfect, *c.* 1884. This man appears to be working on his serve. Proper tennis attire for men was much more comfortable then the ladies' fashionable outfits.

Two-Handed Forehand, *c.* 1890. This woman's tennis form and dress are perfect. Shown in the background is the Casino bowling alley which was constructed in 1884 parallel to Mathewson Street. The building contained six bowling alleys and two shooting galleries.

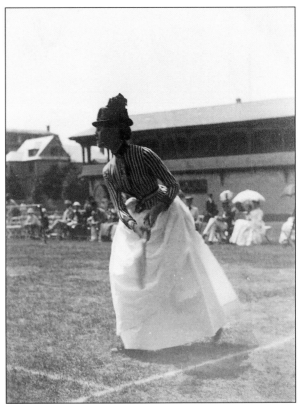

Lawn Tennis, *c.* 1891. "The annual lawn tennis tournaments were being held this week starting at half past ten. The events consisted of gentlemen's singles, gentlemen's doubles and junior singles. Handsome prizes were secured for each event" (*Narragansett Times*, August 10, 1891). This popular sport had become a fad among summer residents. Many of the hotels also provide lawn tennis courts for use by their guests.

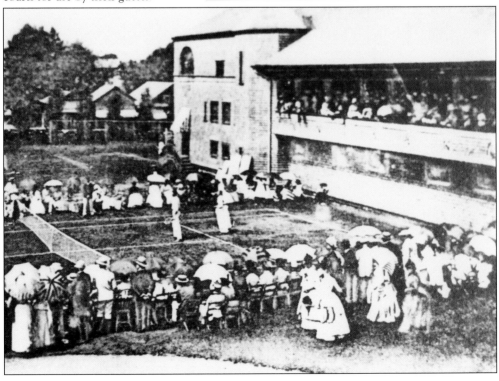

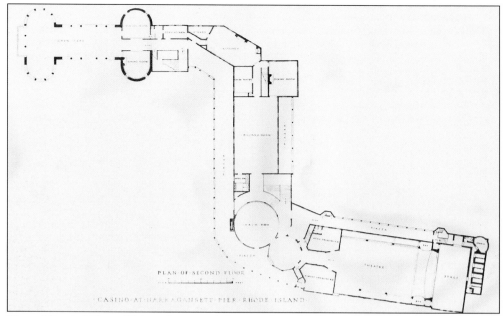

Plan of Second Floor. This architectural drawing from McKim, Mead and White shows their creative use of space to accommodate various functions in the Casino. Broad piazzas tied public rooms to one another and to the open gallery over the stone arch. The 90-by-60-foot theatre also served as a ballroom and concert hall. The first floor contained six large rooms which were leased to merchants and opened out onto Exchange Place.

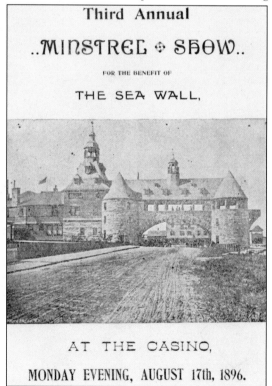

Annual Minstrel Program, c. 1896. This interesting fund-raising advertisement is a clue to the civic responsibility shared by the summer residents. Ocean Road badly needed a proper seawall, and this was one way to help raise the necessary funds. The Casino theatre provided the ideal site.

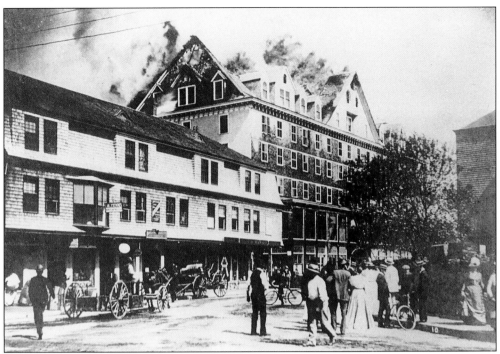

Rockingham on Fire. Near the noon hour on September 12, 1900, fire broke out on the top floor of the Rockingham. Despite valiant efforts of area fire companies, the Rockingham was soon a mass of flames. Within an hour, the Casino caught fire, and by 2 pm it too was a total loss. The Hazard Block and a row of stores to the north were also destroyed. Firemen confined themselves to saving the remaining portion of the Pier.

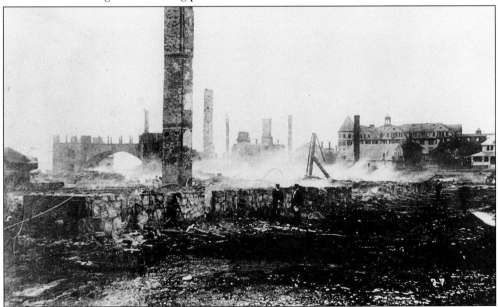

Casino in Ruins, c. 1900. The day after the tragic fire, the Rockingham Hotel and Casino ruins are still smoldering. Stone walls and tall fireplace chimneys are a grim reminder of the beauty and elegance of these great wooden structures.

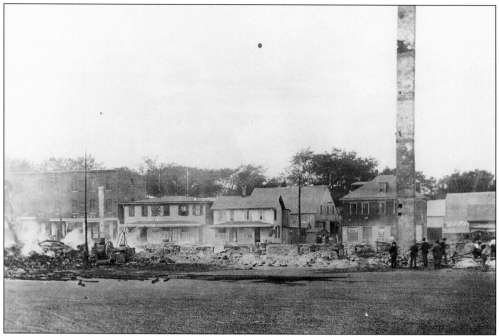

Casino Ruins Looking West, *c.* 1900. "This is the end of the Pier, and many who had reaped golden harvests in past seasons, shook their heads with vague foreboding of the blackness of the future. The casino, it was declared, would never be rebuilt" (*The Evening Bulletin*, Providence, RI, September 13, 1900). It was said to be the "darkest day in the history of the Pier" (*Ibid.*).

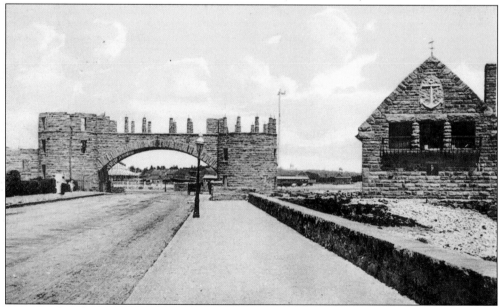

Towers After the Fire. Only the stonework remained. It was rebuilt in 1910 without the stately clock tower. In 1938, a hurricane caused considerable damage to the roof structure, and in 1965, fire once again struck the Towers. However, the stately structure has been restored and remains today an important reminder of Narragansett's historic past, as well as a much loved center of attraction for a hopeful future.

Six

Cottages

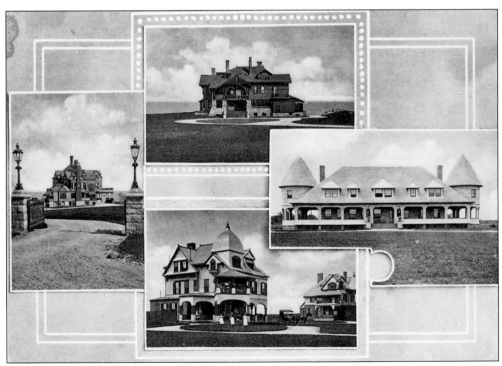

Image from an 1896 Souvenir Booklet. This booklet was designed to entice the reader to explore Narragansett's cottages. When the Spragues decided to build Canonchet, the idea of spending the summer in a private, secluded environment rather than a busy public hotel appealed to more and more of the wealthy summer travelers. By 1887, more than seventy-five cottages had been constructed.

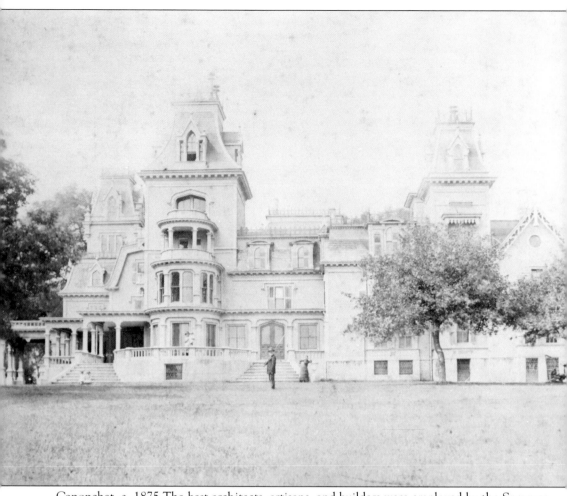

Canonchet, c. 1875 The best architects, artisans, and builders were employed by the Spragues to build the largest, finest, and most unusual summer home in Rhode Island. In 1866, they purchased the William H. Robinson and adjoining Mumford farms which occupied the land between Pettaquamscutt Cove and Narragansett Beach. Magnificent in proportion, peculiar in arrangement, Canonchet stood in the center of a generous park and commanded a panoramic view of Narragansett Bay. The main staircase ran to the top of the four-story mansion, which contained over sixty rooms. The construction cost was reported to be between $650,000 and $1 million. The cost of a typical hotel built during the same period in Narragansett was one-tenth that of Canonchet. All of this grandeur was open to visitors two afternoons each week. It became the permanent residence of Governor Sprague in 1875, but was destroyed by fire in 1909.

Kate Chase Sprague (1840–1899). Kate was the brilliant daughter of Salman P. Chase, secretary of the treasury under Lincoln and later chief justice of the U.S. Supreme Court. Acknowledged by many to be "the most beautiful and influential woman of her day," her stormy marriage to the wealthy William Sprague ended in scandal and divorce in 1882. However, four children were born to the Spragues during their nineteen-year marriage. Kate's dominant role in the design and furnishing of Canonchet makes Narragansett a part of her legacy.

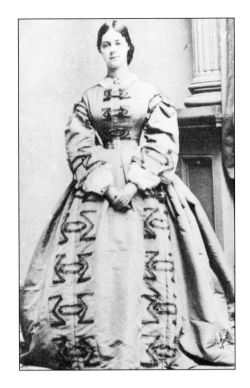

William Sprague (1830–1915). Mr. Sprague was the son of Amasa and Fanny Sprague of Providence. The Spragues were a rich and powerful family who built one of the first cotton mills in Rhode Island and developed an extensive manufacturing empire. William became governor in 1860 and financed and lead the First Rhode Island Regiment in the early days of the Civil War. He resigned as governor in 1863 to assume the office of United States senator and married Kate Chase later that same year. After two terms as senator, Sprague made Canonchet his permanent home. He also became the first president of the Narragansett District Council in 1888 and served two terms in that body.

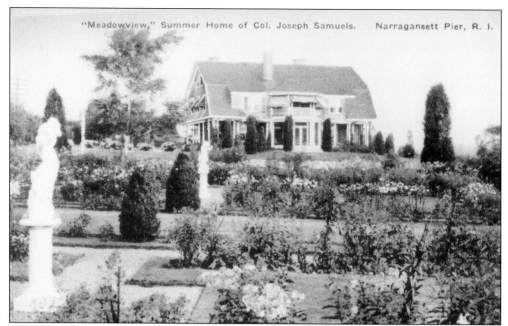

"Meadowview," Summer Home of Col. Joseph Samuels. Narragansett Pier, R. I.

Meadowview, c. 1885. A summer home of Colonel Joseph Samuels, Meadowview was located at 201 Boston Neck Road. The original home designed by John Calvin Stevens was razed in 1996 and replaced with a new structure.

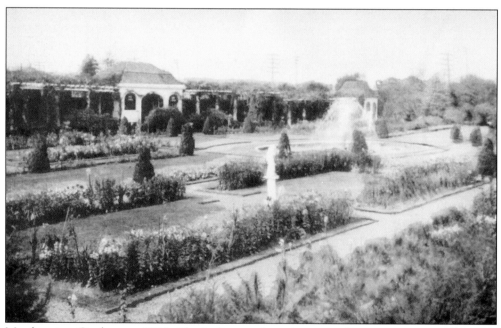

Meadowview Gardens, c. 1900. The Italian gardens shown in this view were a well-known feature in Narragansett. The garden area is mostly grass today. The loggia stands at the southern side of the property as evidence of the estates former grandeur.

Bonnie Bourne Park. Built in 1886 for the Reverend Walter D. Buchanan of New York, these nearly identical pair of wood Shingle-styled cottages are located at 157 Ocean Road. They are still being used as summer cottages.

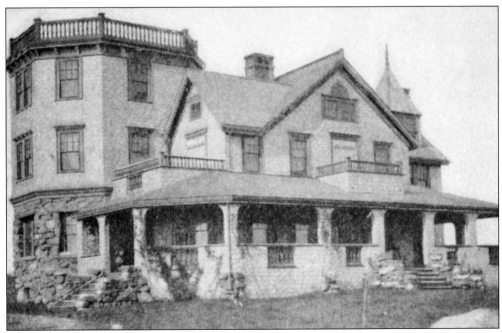

Hillcrest, *c.* 1890. Built for Mrs. E.B. Carver, it was originally sited on South Pier Road west of Gibson Avenue. The house with a unique windmill-like corner tower looks very much like a structure on Rodman Street.

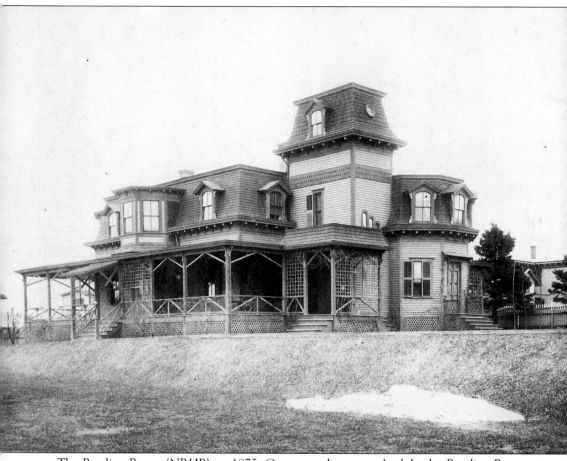

The Reading Room (NRHP), *c.* 1875. Constructed as a men's club, the Reading Room was originally located on Mathewson Street. Moved to its present location at 41 Ocean Road in the late 1890s, it is now a private residence and real estate office also known as Sea Lawn.

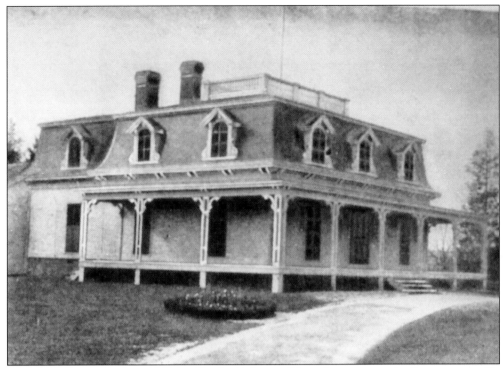

Idlewild (NRHP). Built in 1869 for Charles E. Boon of Providence, it was the first summer villa erected at the Pier by a summer guest for his/her own use and enjoyment. The two-and-a-half-story, mansard-roofed home is located at 40 Central Street.

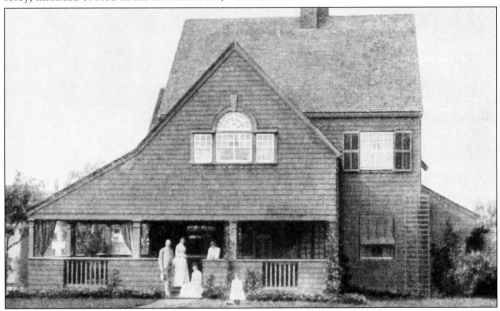

Rosalind (NRHP). Built in 1885 for Nancy K. Bishop of Providence as a rental property, it was later sold to I.R. Grossman of Boston. Mrs. Grossman was the daughter of Edwin Booth, a famous actor of that period, who was an occasional guest at the home, which is located on Central Street.

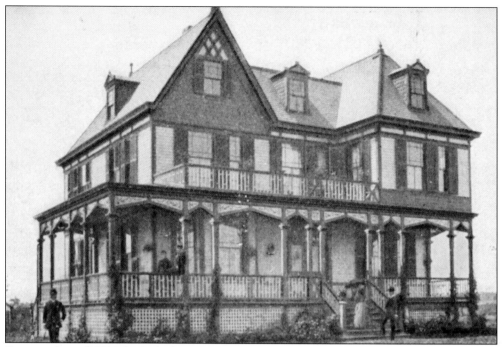

Sonnenschein (NRHP). Built for Emma B. Carver of Philadelphia, it was originally called Kabyun. Typical of Queen Anne architecture, this lovely home is located at 60 Central Street.

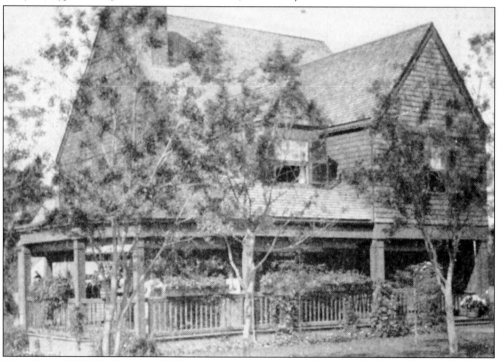

Homeleigh (NRHP). Built in 1885 as a rental property for Nancy K. Bishop of Providence, its design was inspired by seventeenth-century New England architecture. The house is located at 65 Central Street.

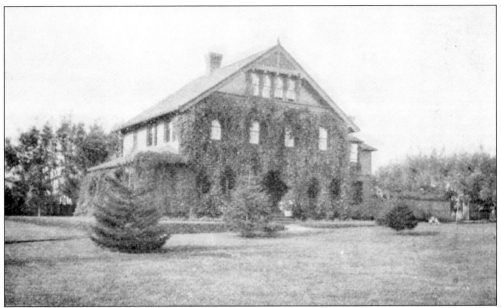

Lasata (NRHP). Built in 1887 for John H. Shepard of New York, this handsome two-and-a-half-story house is located at 94 Central Street. The name is Native American for "house of peace," and for many years the home belonged to the Bouvier family. As a young girl, Jackie Bouvier Kennedy was an occasional summer guest.

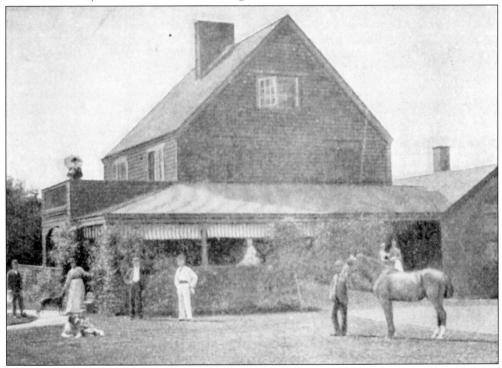

Tyn-y-coed (NRHP). The name of this wood-shingled house is Welsh for "cottage in a field." It was built in 1884–85 for Nancy K. Bishop of Providence as her own residence and is located at 73 Central Street.

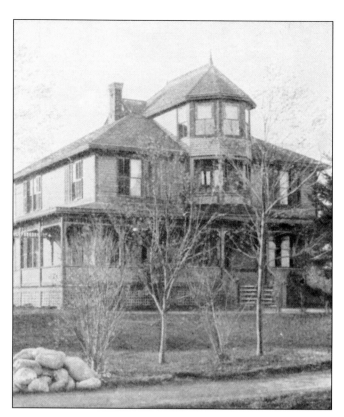

Sunnymead (NRHP), *c.* 1887. Built for the Misses Gwynne of New York, sisters of Alice Vanderbilt, it was the site of many elegant social events. One of the more famous guests was Mrs. Cornellius Vanderbilt, wife of the builder of the Breakers in Newport. The home is located at 106 Central Street.

Windermere (NRHP). Built in 1889 for Stephen T. Caswell, it later became the home of his brother William. This two-and-a-half-story shingled house is located at 116 Central Street.

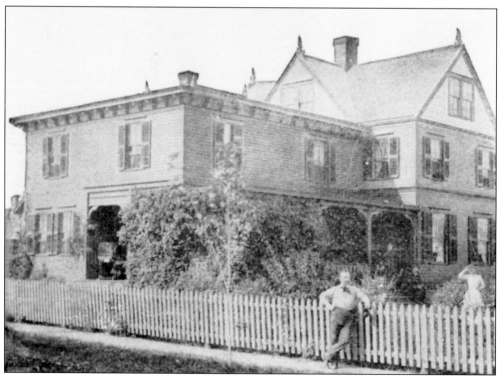

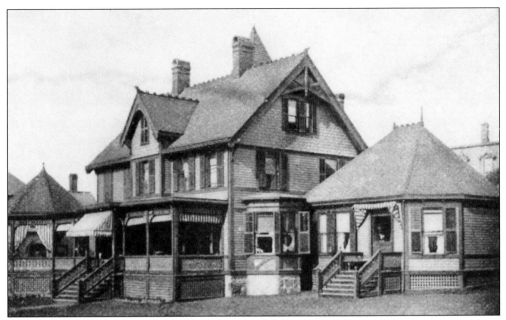

Starr Cottage (NRHP), c. 1883. Built for Mrs. William Butterfield of Chicago as a summer residence, this home is located at 68 Caswell Street. A two-and-a-half-story, gabled-roofed frame house, it has a gabled central pavilion and simple Eastlake-style trim.

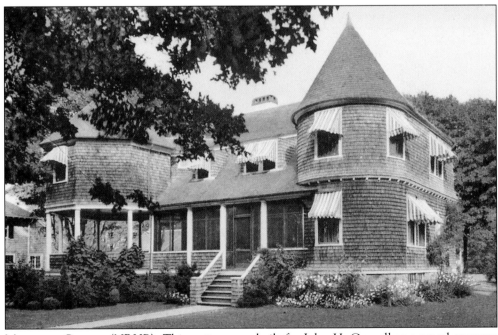

Metatoxet Cottage (NRHP). This cottage was built for John H. Caswell as a rental property in 1885–86. Located at 64 Caswell Street, it was used in association with the Metatoxet Hotel.

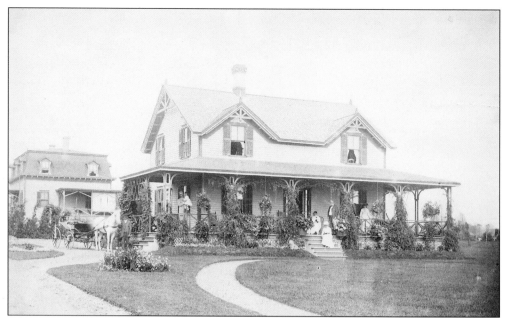

Hopewell (NRHP), *c.* 1875. Built for Dr. Charles Hitchcock of New York, Hopewell is located at 51 Ocean Road. Hitchcock was a prominent summer resident (personal physician to architect McKim), who played an important role in establishing the Narragansett Pier Improvement Association and the Narragansett Casino Association.

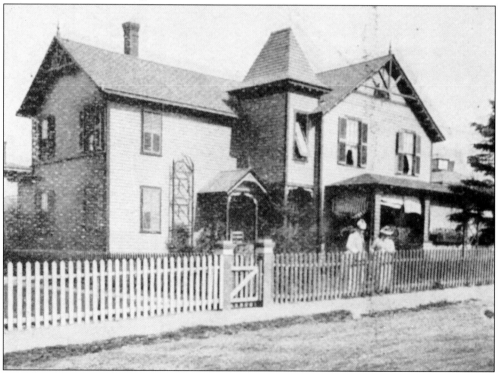

Ninigret Cottage (NRHP), *c.* 1875. Located at 22 Mathewson Street, this modest home was used by summer guests who preferred quiet privacy.

Elmhurst (NRHP),*c.* 1890. Built for J.A. Tucker of Narragansett as a personal residence, this Queen Anne house is located at 84 Central Street.

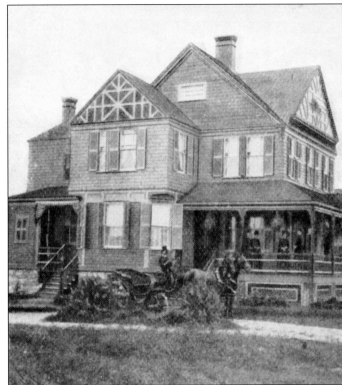

Nirvana, *c.* 1895. This lovely, late-Victorian cottage is located on Kingstown Road and is representative of several such homes in that area.

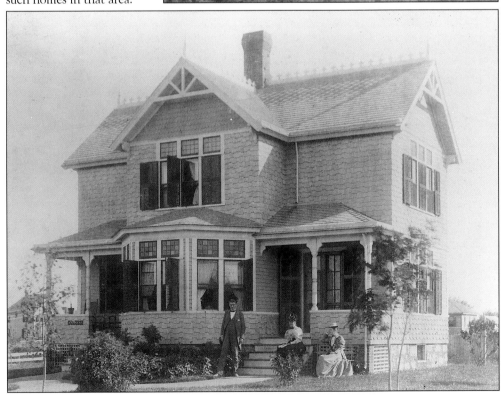

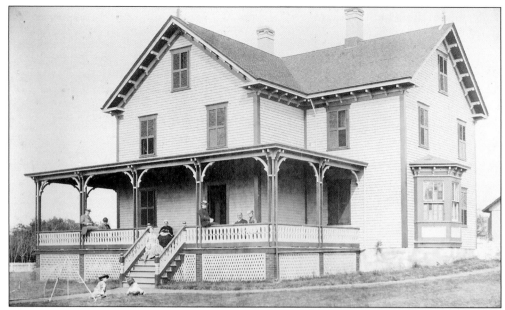

Unidentified Victorian Cottage. Like so many others of its period, this cottage was a two-and-a half-story, wood-framed structure. Young children were often left at home with a nanny while parents were engaged in the social activities of the day.

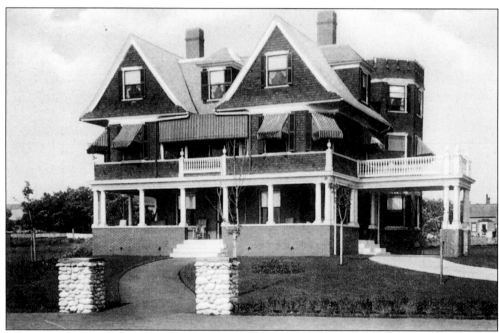

Youghal Cottage, c. 1898. Built for Dr. James E. Sullivan of Providence, this summer residence was located on the corner of Ocean Road and Rodman. The structure is now used as a commercial establishment known as the Pier House Inn.

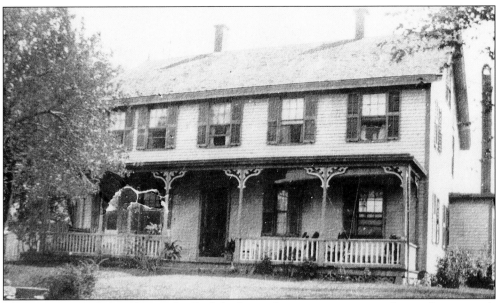

Clayton Cottage (NRHP), *c.* 1874. Built by James Cross as a summer residence, this two-and-a-half-story, clapboard-gabled house is a good example of the more modest cottages at the Pier. It is located at 50 South Pier Road.

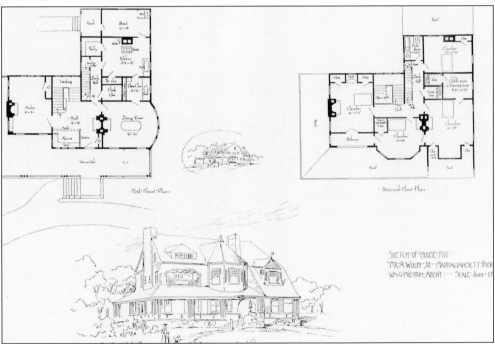

Mon Rêve (NRHP). This Shingle-styled dwelling was designed by William Gibbons Preston for Aaron Wolff Jr., of New York. It was constructed between 1890 and 1895 and is located at 41 Gibson Avenue. Florence Kane, a world-renowned artist subsequently purchased the home and turned the small stable into an art studio on the back part of the property. Kane is best known for her World War II sculpture on the Narragansett Casino and Towers green and the President Eisenhower bronze bust in Washington, D.C.

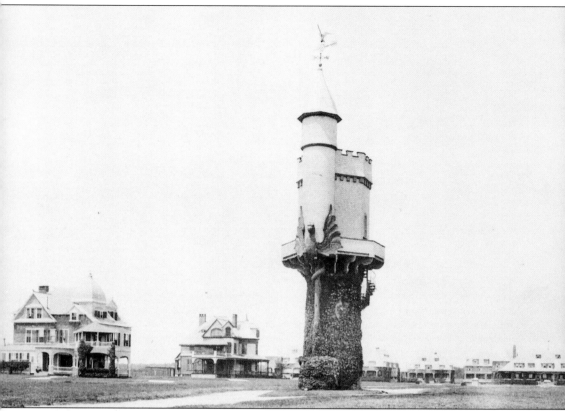

Earlscourt (Earls Court) Water Tower and Cottages. These unique structures were built for James Earl, a New York lawyer, in 1886–87. Mr. Earl was an influential investor in Narragansett and planned an extensive development along Earls Court Road. Four large cottages were constructed before town water became available. Therefore, a water supply, using the cylindrical tower with a decorative wooden water tank and giant bronze griffin, provided for the development. The concept of a group of summer cottages with shared common services illustrates an historically significant trend in Narragansett. A fire in 1912 started in Sherry's casino (at the far right of the photograph), spread to Earls Court, and burned three of the four original cottages. One was subsequently rebuilt. The bronze griffin was lost years ago and the 1938 hurricane removed the top-part of the tower.

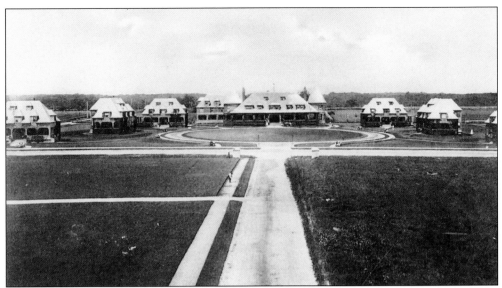

Louis Sherry Cottages (NRHP) on Kentara Green. Built in 1888–89 by Louis Sherry, this complex is located on Gibson Avenue. The architects were McKim, Mead and White (who designed the Narragansett Casino and the Rhode Island Statehouse). The six cottages formed a symmetrical site with a distinctive Swiss Moorish style of architecture. The large central structure was a combination casino and restaurant that could serve the public as well as the guests staying at the cottages. A 1912 fire burned the casino and three cottages. One was rebuilt leaving four surviving dwellings.

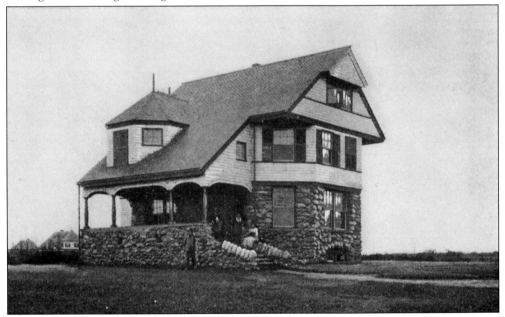

Gardencourt (NRHP), c. 1888. Designed by William Gibbons Preston for Charles H. Pope of New York, this house was one of five structures proposed for a large site at the intersection of Gibson Avenue and South Pier Road. Gardencourt was the only home built, and Fredrick Law Olmsted was engaged to design the landscape and gardens. In the 1980s, the estate was converted to condominiums and named Gibson Court.

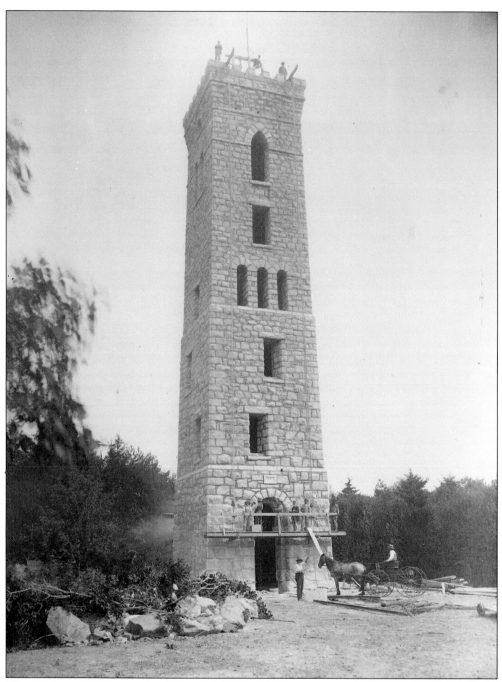

Hazard Memorial Tower (NRHP), c. 1884. This 105-foot, square granite tower is an important local landmark. Started by Joseph Peace Hazard, it was completed about 1884 and dedicated to the memory of the Hazard family ancestors. The tower was part of a complex of stone structures comprising Sea Side Farm. During his numerous travels abroad, Hazard would return home with varieties of trees, shrubs, and fauna, which he would maintain about his estate. In 1872, "4,000 ornamental trees were added to the grounds, and 150 bushels of grapes were harvested from the farm" (*Genealogical, Family, and Personal Notes: Joseph Peace Hazard's Journal, c. 1890*).

Joseph Peace Hazard (1807–1892), son of
Rowland Hazard. One of the seventh
generation Hazards that settled in Narragansett
Country, Joseph took his turn managing the
family mill complex in Peace Dale. However,
he felt much closer to the things of nature
and spent most of his life developing Seaside
Farm, a large estate that stretched from
Narragansett Bay to Point Judith Road. He
left a legacy in stone, marking streets from
Ocean Road to Point Judith with engraved
granite markers. He was a kind, gentle man
who was both frugal in personal matters and
generous towards others.

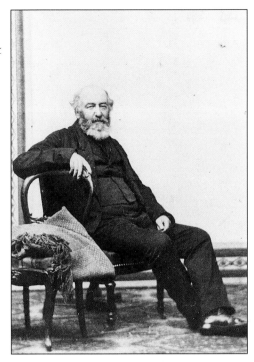

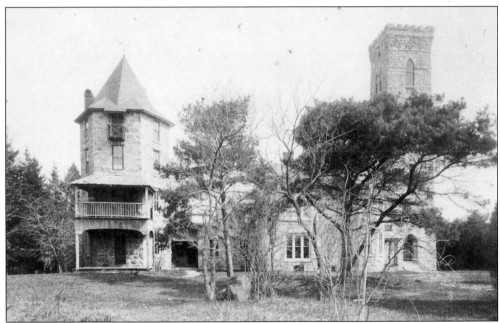

Hazard Castle (1846–1884). Built by Joseph Peace Hazard as the main house for his Sea
Side Farm, it was modeled after an English abbey. The castle-like structures became a
favorite attraction for summer visitors to Narragansett. The hexagonal tower on the left
was constructed 1848–49 in memory of his mother. The Roman Catholic Diocese of
Providence acquired the estate on Hazard Avenue, and it is known today as Our Lady of
Peace Retreat House.

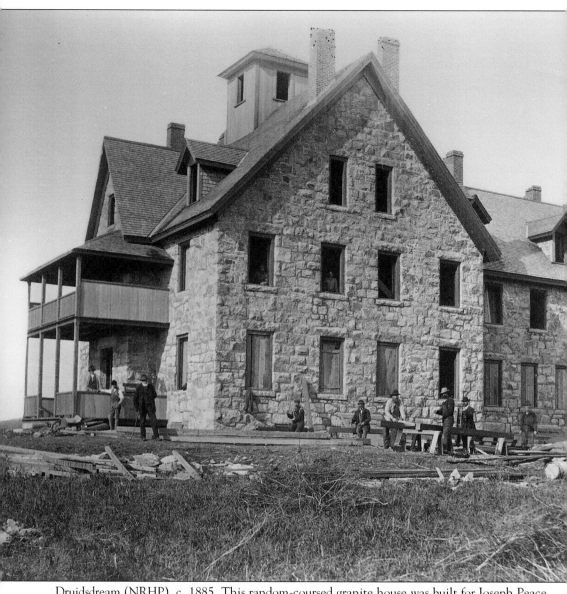

Druidsdream (NRHP), *c.* 1885. This random-coursed granite house was built for Joseph Peace Hazard and is located at 144 Gibson Avenue. "I named the lot 'Druidsdream,' since new year of 1884, I think—and intend to have that name inscribed upon the stone caps of the front door of this house. This title applies to the locality rather than to this new house" (*Genealogical, Family, and Personal Notes: Joseph Peace Hazard's Journal, c.* 1890). It was not built for his personal residence but "for others who would have need of it" (*Ibid.*). The granite came from his own quarry at Sea Side Farm. This unusual home is now a private residence.

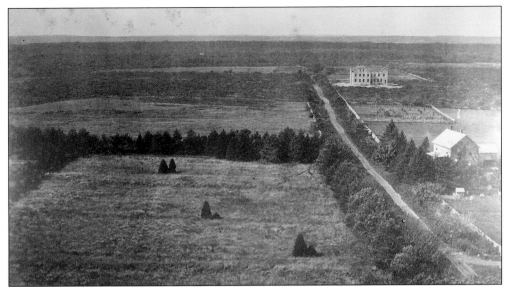

This photograph, looking west from Hazard's Memorial Tower, was taken in 1884. Near the top of the picture is Druidsdream under construction. The farmhouse in the foreground is an eighteenth-century building used by tenants of Sea Side Farm. The nature and character of farmland in Narragansett can be clearly seen.

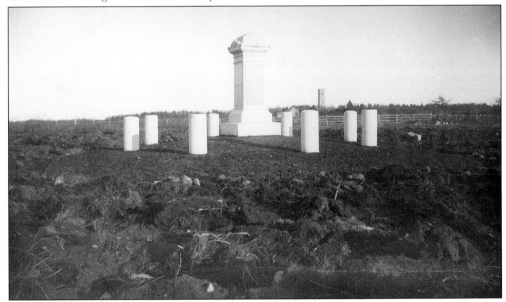

Kendal Green, c. 1883. Originally constructed as an antemortem or planned cemetery for Joseph Peace Hazard, this site is located on Gibson Avenue across from Druidsdream. The granite monument was 13 feet tall and surrounded by eight fine granite pillars. Every other pillar has a concave top to collect rainwater for the birds. Mr. Hazard decided just before his death to be buried near family in Portsmouth, Rhode Island. The monument was removed and the site preserved for a bird sanctuary. "It is said, Mr. Hazard introduced the English Sparrow in this country" (*Genealogical, Family, and Personal Notes: Joseph Peace Hazard's Journal*, c. 1890). Among the first to foresee Narragansett as a popular watering place, he fully supported its development and early growth.

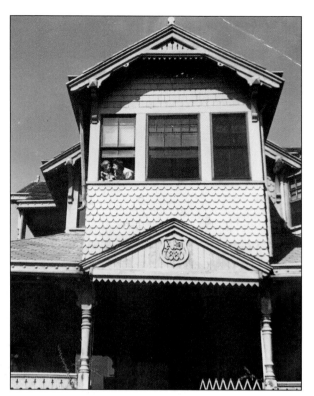

Whimsey Cot, c. 1880. Built by Rowland Hazard as a summer home, the Shingle-styled cottage is illustrative of the decorative architectural features of the period. Located on Ocean Road within the Hazard compound, it has been heavily damaged by hurricanes and significantly altered.

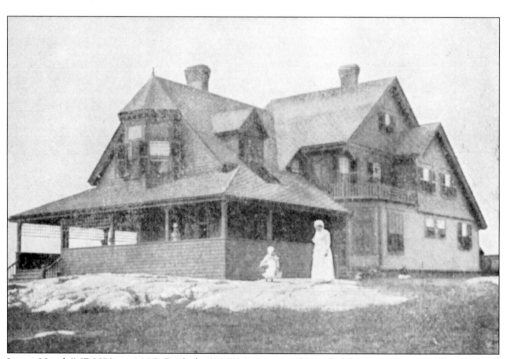

Lions Head (NRHP), c. 1885. Built for W.W. Newton of Pittsfield, Massachusetts, this home is located at 59 Newton Avenue overlooking Narragansett Bay.

Sea Meadow (NRHP). Located at 11 Newton Avenue, this home was built for James W. Cooke of Philadelphia in 1885–86.

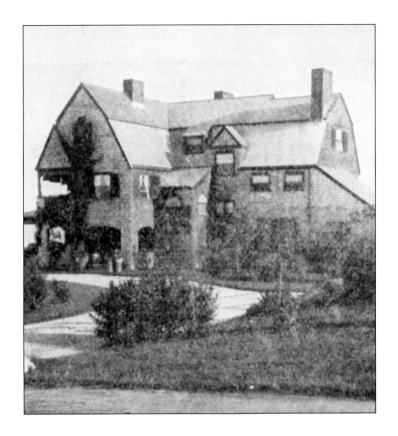

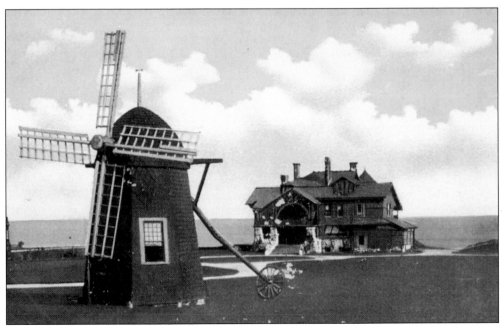

Rockledge. This oceanfront home was built in 1888 as a residence for E. Harrison Sanford of New York. It was located on Ocean Road until the 1960s when it was razed.

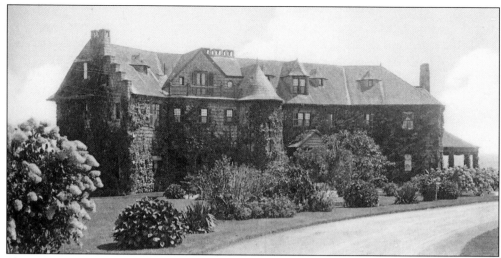

Shore Acres, c. 1891. Originally called Suwanee Villa, this unusual home was the residence of David Stevenson of New York. Located on Ocean Road, it was later purchased by John H. Hanan and for many years was the site of the Pier's most lavish parties. Eventually it was torn down and only the carriage house remains.

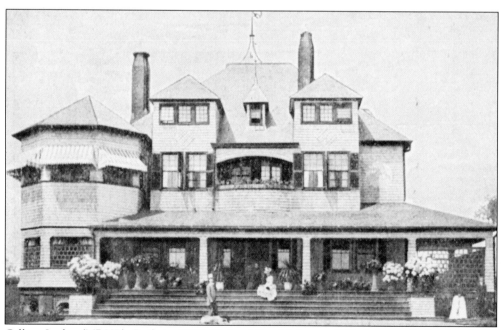

Gillian Lodge (NRHP). Built in 1885–86 for Allan McLane of Washington D.C., this three-story home was designed by McKim, Mead and White. It is located at 421 Ocean Road.

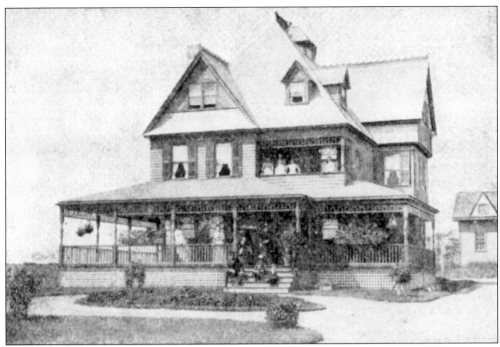

Woodburn, c. 1886. Built for A.M. Cunningham of New York, this summer cottage was located just south of Gillian Lodge on Ocean Road. It has since been razed and replaced with a twentieth-century home.

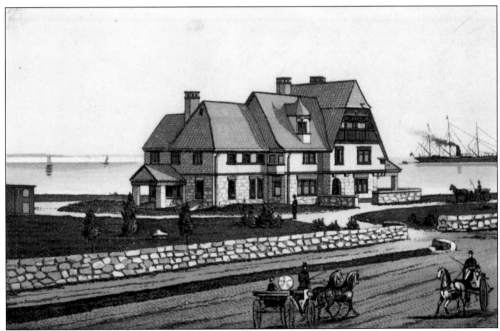

Stone Lea (NRHP), 1883–84. Designed for George V. Cresson of Philadelphia by McKim, Mead and White, this stone-and-wood-frame, Shingle-styled cottage overlooks the ocean. It is located at 55 Newton Avenue and has become a bed and breakfast establishment.

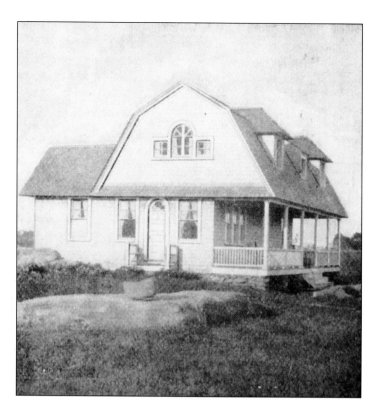

The Barnacle, *c.* 1891. This modest cottage was constructed on high ground near the north end of Narragansett Beach. It exhibits both Shingle style and bungalow design and is situated at 255 Boston Neck Road.

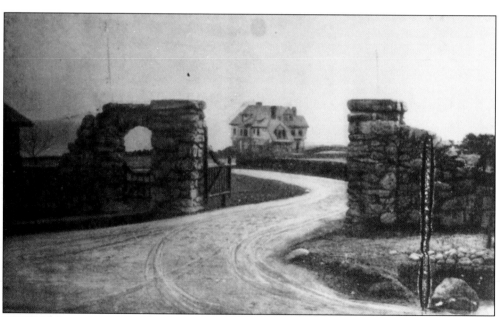

Wildfield Farm (NRHP). This large Shingle-styled, Queen Anne cottage was built in 1887 for Mrs. Samuel Welch of Philadelphia. A large stone stable near the artistic stone gateway to the entrance of the property is now a private residence. These structures are located on Wildfield Farm Road.

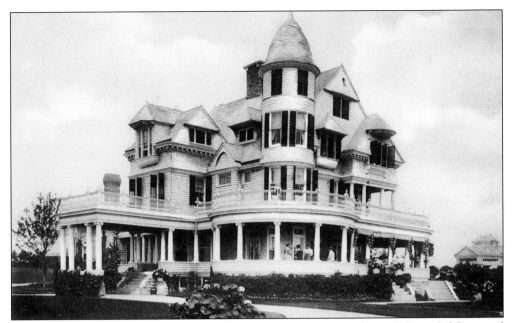

Dunmere, *c*. 1884. Dunmere was a 13-acre estate owned by Robert G. Dun (of Dun and Bradstreet). The property contained several major structures set amid landscaped grounds and a man-made lake. It was called "the show place of the Pier." A destructive fire in 1929 severely damaged the main house, and a modern home was subsequently built at the site on Ocean Road.

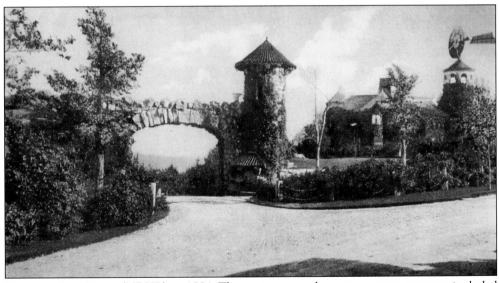

Dunmere Gate House (NRHP), *c*. 1884. This picturesque, three-story, stone structure included a wooden water tower complete with a windmill. The windmill is gone, but the gatehouse remains as a private residence.

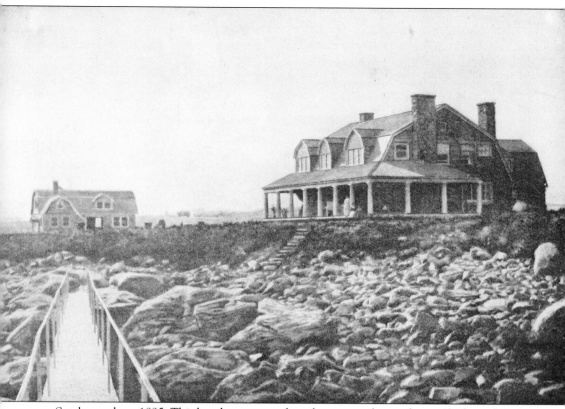

Scarborough, c. 1895. This handsome oceanfront house was the residence of Edmund W. Davis of Providence. Located just north of Scarborough Beach, it was destroyed by fire. The carriage house, on the left in this photograph, was later used as a restaurant. The stone walls remain today as a haunting reminder of the Pier's Cottage era.

Seven

People and Places

Field Trip to Canonchet, c. 1895. This group of schoolchildren and their teachers posed on the front steps of Canonchet. Kate Chase Sprague started opening the mansion twice a week to the public. The tradition continued with Inez Sprague, Governor Sprague's second wife. This wonderful tradition was especially appreciated by schoolchildren who were exposed to one of the most remarkable buildings of its time. A charitable fund for children, also started by Inez Sprague, still exits today.

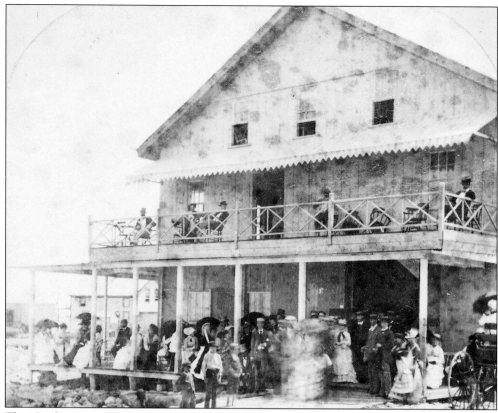

The Studio, *c.* 1879. Located at the north end of Ocean Road (on the beach), this establishment was the place to go after the bathing hour. An upper room contained billiard tables and a bar, while the lower floor was devoted to lunch and supper rooms. When the Rockingham Hotel expanded to the east, the Studio (also known as Billington's) was moved to Narragansett Avenue.

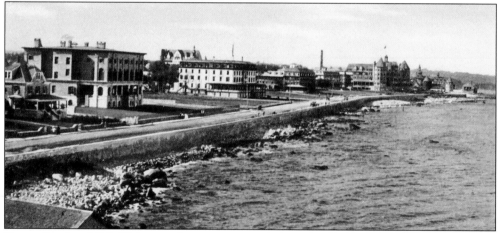

Ocean Road, *c.* 1899. This waterfront view extends from the Carlton Hotel on the left to the Narragansett Casino and Towers on the right. It represents the high point of Narragansett's development as a seaside resort. Time and events in the twentieth century would mark both the decline and renewal of this remarkable place.

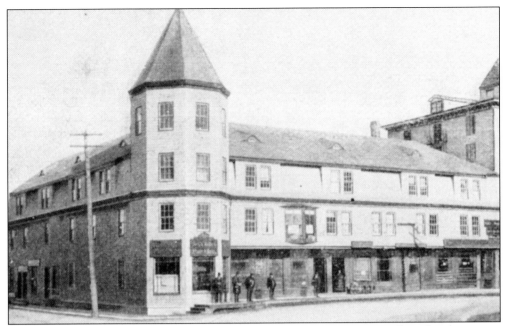

The Hazard Block, *c.* 1895. Located on the site of the present U.S. Post Office, this three-story building contained business on the first floor and guest rooms on the upper floors. Built in 1890, it had a short history of only ten years before burning in the devastating fire of September 1900.

Coggeshall Family, *c.* 1900. Posing in front of their home near Perkins Avenue are, from left to right, Abby S., Edward Everett, and Jonathan Lawton Coggeshall. The sturdy home remained in the Coggeshall family for eighty years and still provides a comfortable abode.

Saint Peters by-the-Sea Church (NRHP). This beautiful stone structure was dedicated in 1872. Modeled after English country churches, it contains several remarkable stain-glass windows (most notable are the Tiffany windows) and a bronze relief cast by Florence Kane. Located on Central Street, it remains today a vibrant focus for the Episcopal faithful.

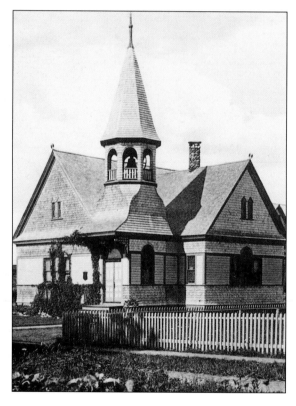

First Baptist Church (NRHP). Erected in 1889 or 1890 on Caswell Street, this lovely wood-shingled church was converted into a private residence in the 1960s.

First Baptist Church, Point Judith, R. I.

HAROLD G. HIGH. MINISTER

Regular Services.

Sunday:—Bible School, 10 a. m. Preaching, 11 a. m. and 7 p. m.
Saturday:—Prayer Meeting, 7 p. m.

EVERY Service is for YOU, and depends on your presence for its success. Both suggestion and criticism are desired that the meetings may be of the greatest value.

DO YOUR PART.

The Subjects for Sunday Evenings during April will be:

April 4.—THE CROSS ; Its Victory.
April 11.—THE CROSS ; Its Defeat. (Special Easter Music)
April 18.—THE CROSS ; Its Meaning.
April 25.—THE CROSS ; Is there One for Me?

And whosoever will, let him come.

Point Judith Baptist Church, c. 1878. This calling card from the church pastor was an inviting introduction to worshippers. "The church was built to save Neck residents the long trip to Wakefield for church" (*Historic and Architectural Resources of Narragansett,* 1991) Centrally located on Point Judith Road, the church served a sizable rural farm population.

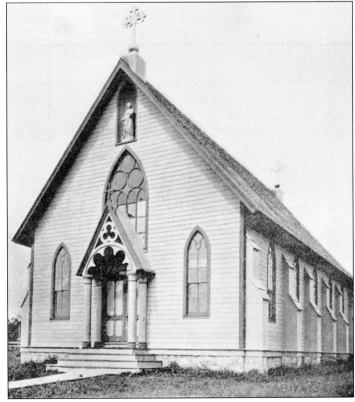

Saint Philomena's Church, c. 1895. Constructed as a summer church in 1883 for Catholic parishioners, it was later converted to other church use when the present edifice was erected in 1908. Located on Rockland Street, the structure was taken down in 1977.

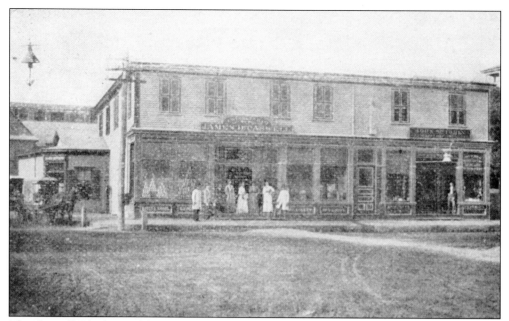

The Caswell Block. Established in 1870 by J.D. Caswell, this early business was located on Exchange Place. Caswell, one of several merchants, maintained a grocery store and additionally sold dry and fancy goods, bathing goods, boots and shoes, men and women's clothing, and even awnings and tents made to order. Orders were delivered free of charge for summer and permanent residents.

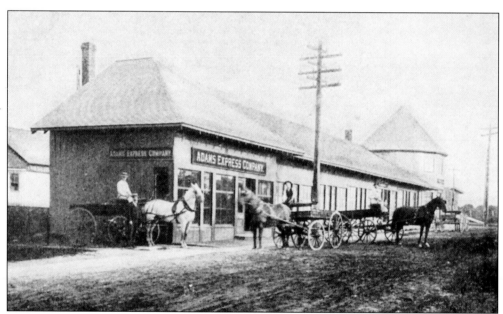

Adams Express Office, c. 1885. The office was located in the Central Block, which was on Boon Street across from the NPRR station. Several wagons would have to meet each train arrival to shuttle trunks and other baggage to the various hotels. The process was repeated when visitors departed.

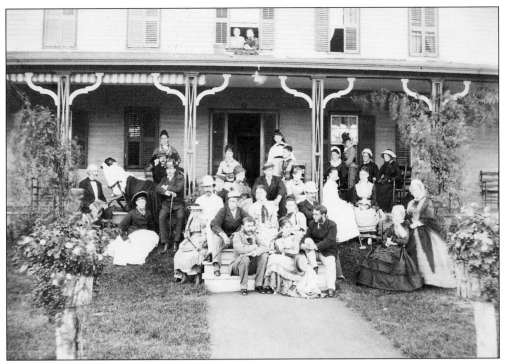

Narragansett House Guests, c. 1875. It was common for several related families to occupy a guest house at the same time. Often two and three generations of a family would vacation together. This wonderful photograph is an interesting study of such an occasion.

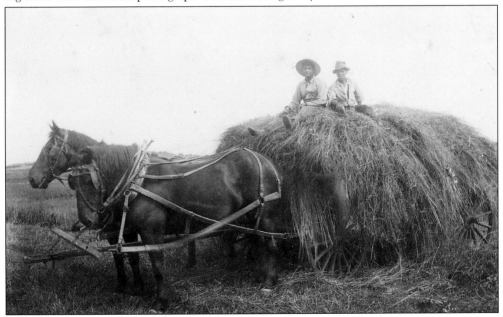

Bringing in the Hay, c. 1885. Agriculture maintained a prominent role in nineteenth-century Narragansett. Gathering seaweed from the extensive shorelines of Point Judith Neck was also profitable. It was extensively utilized as a fertilizer and would occasionally be used as livestock fodder.

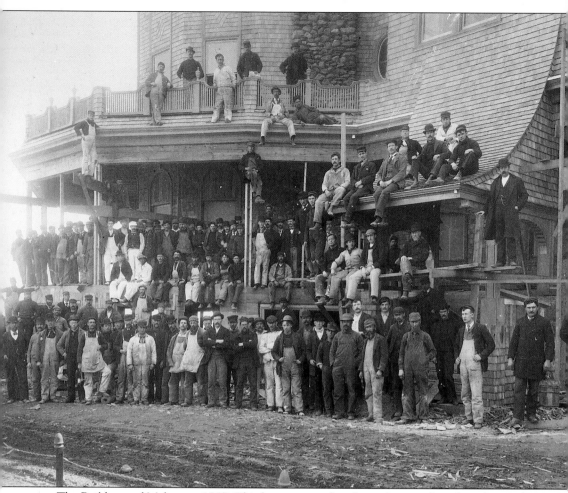

The Builders and Makers, *c.* 1897. This large group of workmen have gathered on the northeast corner of the "new" Mathewson Hotel to record its last modification. The huge work force required to "rebuild" hotels during the off-season provided steady work for hundreds of local men. Construction of cottages and other business establishments in Narragansett proceeded with little interruption for the next twenty years. However, by 1900, the boom in hotel construction had peaked.

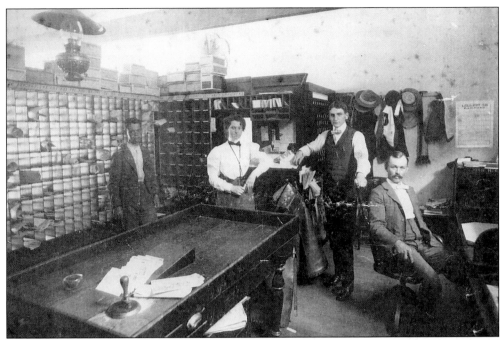

Inside the Post Office, c. 1895. Early postal operations were carried out on Exchange Place and on Kingstown Road. Following construction of Clarkes in 1890, the post office was moved there and occupied space on the first floor. In 1915, the present post office building was constructed.

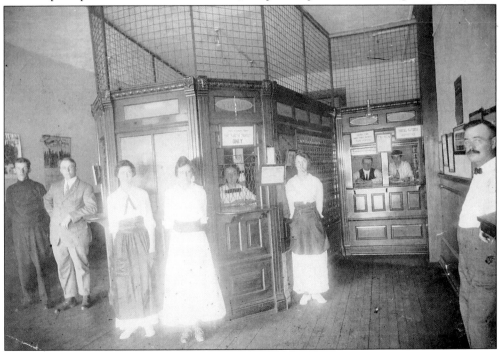

Post Office Lobby, c. 1895. Patrons and clerks pose for a photograph. Walter T. Caswell is second from the left. James T. Caswell is the man at the far right. Summer hours were 6:30 am to 8:00 pm.

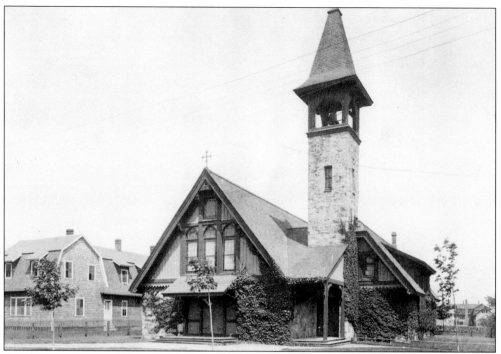

Presbyterian Church (NRHP). Designed by Ware and Van Brunt of Boston, it was constructed between 1875 and 1881 on the corner of Boon and Rodman Streets. It was heavily damaged in the 1938 hurricane and a subsequent fire. To the left of the church is Seafield Cottage, which is one of three in a cluster arrangement on Boon Street. Before the church, Canonchet Hall stood on the lot and hosted roller-skating and other sporting events.

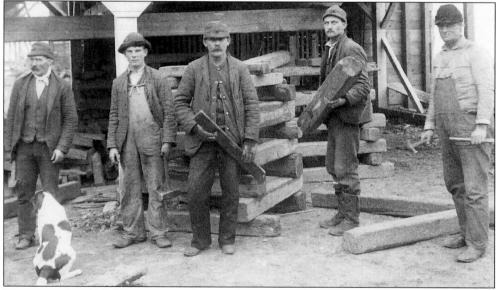

The Movers and Shakers, c. 1890. An unlikely solution to the needs of a changing a hotel economy was to jack the buildings up and move them by ox teams to a new location. Mr. Herbert Webster, a local building mover, (shown in the center) was kept busy. The photograph shows a moving crew in the early stages of raising a building.

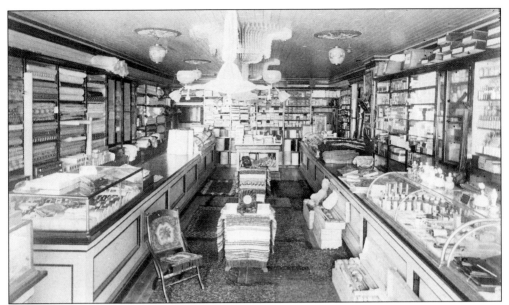

Davis Pharmacy, c. 1900. Located on the first floor of Clarkes on Beach Street, this early version of a drug store sold many related items to both summer and year-round residents. Frank Watson was also a druggist with a store across from the Casino. The medical needs of a growing summer population were addressed by at least three doctors who saw their patients from cottages in the area. In 1888, the doctors listed were as follows: Charles Hitchcock (Hopewell Cottage), Bache Emmet (Clarke Cottage), and St. Clair Smith (Metatoxet Cottage).

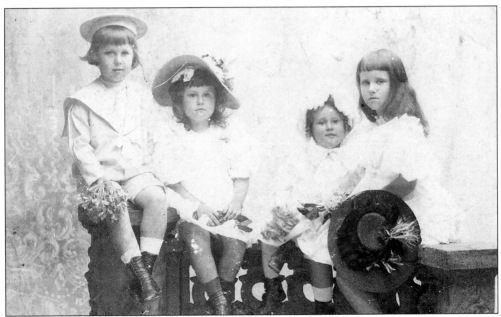

Randolph Family Children, c. 1895. The children of Philip S.P. Randolph Sr. and Hannah Featherstone Randolph pose for their portrait. From left to right, the children are as follows: Philip, Hannah, Emilie, and Dorothy. Their father was a founder of the Point Judith Country Club and an important supporter of the development of Narragansett as a summer resort.

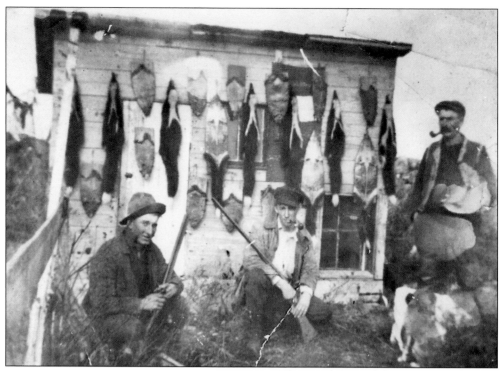

The Local Gun Club. Hunting and trapping of small fur-bearing animals were profitable part-time occupations for some men. A myriad of ponds, creeks, and marshland created the perfect habitat for a rich abundance of animals. This trio displays their catch in front of an old trapper's cabin.

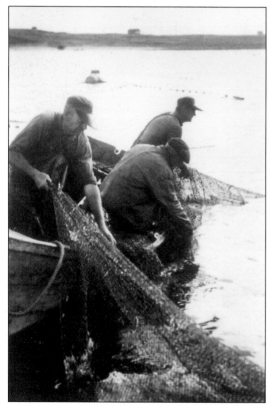

A Fisherman's Paradise. Fishing was a natural adjunct to farming and could occupy time not required to maintaining the farm. The great variety and abundance of sea life which populated the waters off Narragansett supported an important industry which would develop profoundly in the twentieth century.

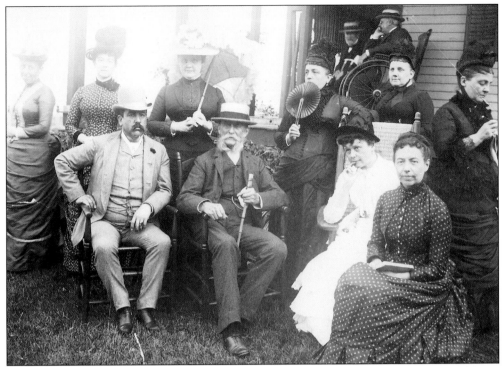

Hitchcock Family, c. 1880. Dr. Charles Hitchcock (seated in the center of the photograph) was a prominent New York physician who regularly spent summers in Narragansett. He also played an important role in founding the Narragansett Casino Association.

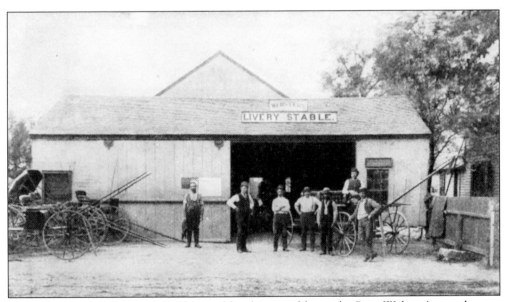

Webster's Livery Stables, c. 1875. One of five livery stables at the Pier, Webster's was also one of the first. Located on Kingstown Road across from the Gladstone Hotel, it was close to all of the action. An advertisement read, "First-class livery attached with gentle horses. Special attention given to families wishing teams for the summer."

Sarah Boss Knowles, c. 1884. Knowles was a member of one of the oldest families in Narragansett. After the Revolutionary War, Hazard Knowles acquired a homestead at Point Judith, which was property confiscated from a Tory who fled to England. In 1810, the government purchased sufficient land from Knowles for the Point Judith Lighthouse. Sarah married John R. Champlin in 1884 and had nine children.

Photographer's Beach Cart, c. 1890. This rare photograph tells as much about the business of photography as the people photographed. Few escaped the camera of "Reckless Charlie," who was on the beach daily from 11:00 am to 2:00 pm. He also maintained a studio on Kingstown Road opposite the Metatoxet.

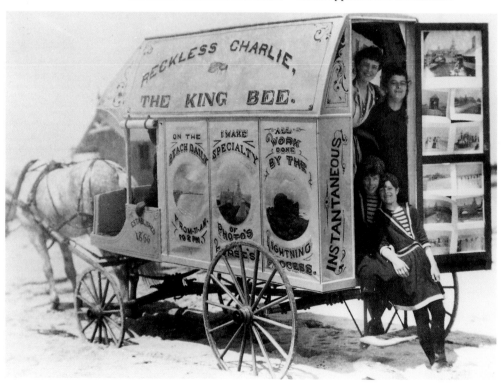

Clarke's Photography, c. 1860. L.H. Clarke's Photograph Rooms at the rear of Narragansett House on Mathewson Street was busy during the Pier's golden era, as was the studio of photographers Hearn and William H. Gurney & Company on Beach Street. Famous Narragansett scenes and people were captured on film by W.B. Davidson and David Davidson. Large-format cameras of the Detroit Photographic Company shot dramatic large-scale photos of Earlscourt Water Tower, Sherry Cottages, and ocean vistas.

Charles F. Thurber, "Reckless Charlie" (1844–1893). Perhaps the most popular photographer at the Pier, he served as a scout during the Civil War and a subsequent Western campaign. It is likely that he acquired the nickname "Reckless Charlie" during this period of time. His photographs of hotels and cottages filled souvenir books, and his pictures of people found their way into countless homes.

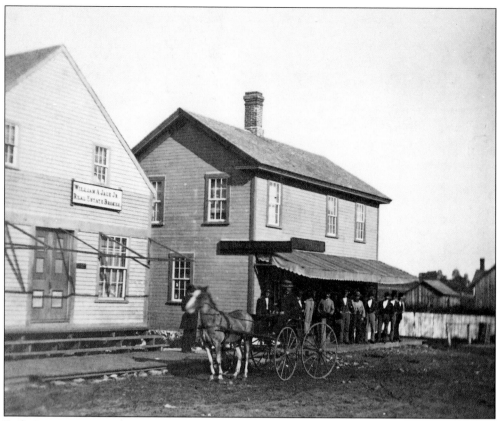

Early Business on Beach Street, *c.* 1870. The store on the right was T.A. Caswell's market. On the left was William A. Jack Jr.'s real estate office.

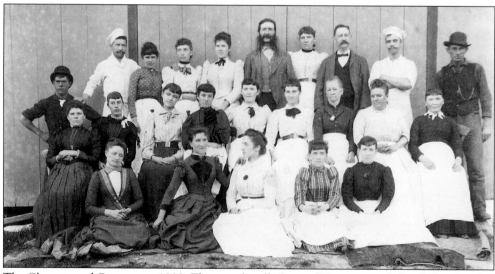

The Cleaners and Caterers, *c.* 1880. The proud staff of one of Narragansett's family hotels takes time out for a photograph. Cooks, clerks, maintenance men, and maids were all very important in the summer resort business.

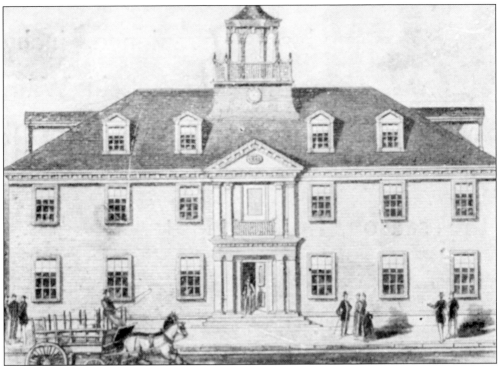

Old Town Hall, c. 1895. Constructed in 1891, the original structure was believed to have been on Fifth Avenue and later moved to Rodman Street, where it served long and faithful the functions of town government until 1979. A new town hall was located in the Fifth Avenue School, and the handsome Old Town Hall was torn down. Narragansett was part of South Kingtown until 1888, when it became a district. In 1901, it was established as the Town of Narragansett.

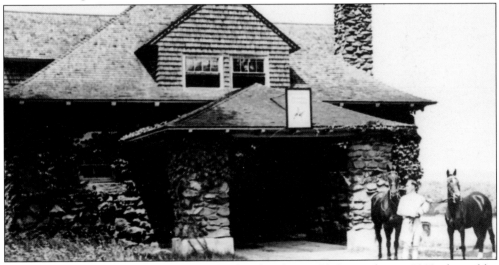

Canonchet Stables, c. 1900. Spared by the fire that destroyed Canonchet in 1909, the stables remained in use for many years and were the site of a "riding school." A later fire has left only the fieldstone walls to remind us of the beauty of the building which is located near the present South County Museum.

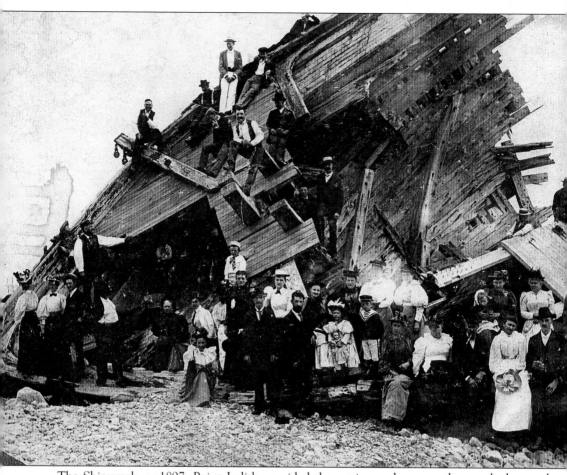

The Shipwreck, c. 1897. Point Judith provided the setting and a prop, the wrecked coastal schooner, for a family reunion photograph. Members of the Whaley, Stedman, and Brown families are present. Oliver H. Stedman, noted author and historian, is the young lad in the sailor suit near the center of the picture. Known as the "Graveyard of the Atlantic," Point Judith was the site of hundreds of shipwrecks. A few of those recorded include: *American Eagle*, 1870; *Catherine W. Mary*, 1876; *Venus*, 1877; *Cuckoo*, 1882; *Allen Green*, 1886; *Anita*, 1888; *Mars*, 1892; *Edward M. Laughlin*, 1898; and *Swallow*, 1900.

The Light Keepers, c. 1890. Henry Whaley and his wife Laura pose at the entrance to Point Judith Lighthouse. Whaley became keeper in 1889 and served until 1910. His father "Captain" Joseph Whaley had served in the same position from 1862 to 1889. Before electricity, the job of keeping the light was arduous. Ten lamps fueled first by whale oil and later by kerosene had to be filled, cleaned, and trimmed each day. In addition, the revolving light was powered by a 288-pound weight that had to be rewound every day. There were no holidays for the keepers. Like the keepers of the light, historians and photographers have kept alive the many images of the past. With gratitude, we close this chapter of Narragansett's colorful history.

Acknowledgments

Narragansett's colorful past could only be documented in this book through the effort and support of many wonderful individuals who have a loving and lively interest in its history.

My first acknowledgments must go to Representative Leona A. Kelley, Aclon "Coggie" Coggeshall, and Charles "Ted" Wright, whose wealth of knowledge, resources, and encouragement opened the right doors to the past and patiently guided me through to the finish.

My heartfelt appreciation to all who so willingly shared their treasured photos, collections, and memories, including the following individuals and families:

the Champlin family
Priscilla Chappell McClellan
Barbara Culatta
Ben Curtis
Eva Doran
Velma Flanagan
Rose Ann Gamache
Anthony Guarriello
Gary Irish Graphics, Boston
Robert Owen Jones
the Hazard family
Marys (Hitchcock) Hoagland
Milton A. Kelley
Pat James
Grace Jordan

Mike Maynard (USCG)
Emilie Randolph Stevenson
John Miller
Lt. Stephen Nash
Thomas Peirce
Timothy Philbrick
Don Southwick
Charisse L. Thompson
William Webster
Jack Westcott
Marge Vogel (RI Originals)
Philip S.P. Randolph III
Barbara Rush
Marise W. Sykes

Rhode Island has outstanding historical organizations and public libraries. The carefully researched procurement and preservation of historical material was invaluable to me in the preparation of this book.

Many thanks also to the following organizations: Kingstown Camera, Narragansett Chamber of Commerce, Narragansett Fire Department, Narragansett Historical Society, *Narragansett Times*, Palisades Mills, Peace Dale Library staff, Providence Public Library, Pettaquamscutt Historical Society, South County Museum, Town of Narragansett staff, URI Graduate School of Oceanography, and the Rhode Island Historical Preservation Commission.

To the memory of Narragansett's past historians
who left us a great legacy in words and images:

Horace "Stubby" Caswell, Kenneth Chappell,
Winifred J.W. Kissouth,
Roger Potter, and Oliver Stedman.